A–Z
OF
SWANSEA

PLACES - PEOPLE - HISTORY

Geoff Brookes

AMBERLEY

I would like to dedicate A–Z of Swansea to the
A–W of our grandchildren: Alex, Bethan, Emily,
Jessica, Isabelle, Matilda, Sam and Will.

First published 2016

Amberley Publishing
The Hill, Stroud, Gloucestershire, GL5 4EP
www.amberley-books.com

Copyright © Geoff Brookes, 2016

The right of Geoff Brookes to be identified as
the Author of this work has been asserted in
accordance with the Copyrights, Designs and
Patents Act 1988.

ISBN 978 1 4456 5599 4 (print)
ISBN 978 1 4456 5600 7 (ebook)

British Library Cataloguing in Publication Data.
A catalogue record for this book is available
from the British Library.

Typesetting by Amberley Publishing.
Printed in Great Britain.

Contents

Introduction

This is not *the* definitive A–Z of Swansea. Even if such a thing could be possible, this isn't it. This is my version. It includes stories from our past, which I have selected because they appealed to me. Some are largely unknown and some a little more familiar; they are linked, as advertised, by their connection with letters of the alphabet. So the book won't give a complete picture of Swansea's fascinating past, but that was never its intention. I hope that you will find the book entertaining and interesting and be encouraged to find out more of what has made us what we are.

As much as possible, this book has been compiled from contemporary sources, and I must acknowledge the support of others who have helped me find them. The book would never have been written without the considerable support of the Swansea Central Library and the West Glamorgan Archive Service – two irreplaceable treasures that must receive unquestioned and sustained support. You will agree too that Jason O'Brien's artwork is wonderful and brings so much quality to this book; it is a privilege to associate my work with his. You can clearly see where real talent rests.

With considerable regret, I must confirm that my book does not include an entry on the cast of the show at the Swansea Empire in March 1897. The show featured the excitingly named variety act 'Brookes and Duncan', although I fear that in the history of popular entertainment their names were written in sand and not carved in stone. Nonetheless, I know you will be pleased to learn that they 'gave an amusing turn ... the attack from the rear with the cannon was very funny'. Inevitably, however, they were upstaged by the next act, Miss Hetty King, who sang 'a laughable Irish song of what would be done with the poker to Patsy'. The following month the show moved on to Cardiff, where audiences have always been less sophisticated. There they shared the bill with a 'whistling comedian' and a 'burlesque wrestling lion', but I believe that their visit to Swansea would have been etched in their memories.

My decision to omit such a central event from our past confirms the limitations of this book.

A

The Assembly Rooms

The Assembly Rooms in Cambrian Place were part of Swansea's unsuccessful attempt to turn itself into a fashionable holiday resort at the start of the nineteenth century. They were designed to appeal to the affluent people of the town by providing a safe and comfortable space for public gatherings, dancing, concerts and playing cards. Swansea's finest had previously gathered in rooms in the Mackworth Arms in Wind Street, and they were keen to create something to rival the Bath Assembly Rooms, which had been completed in 1771 – 'the most noble and elegant of any in the kingdom'. Sadly, their ambition remained forever unfulfilled.

In July 1804, an advertisement in *The Cambrian* newspaper invited people to invest in the project, but things did not run smoothly. It took eighteen years before the rooms were completed – just as the possibility of turning Swansea into an appealing destination disappeared into the smoke of industrial development. They might have been well positioned, facing gardens and promenades, but by 1815 they were regarded as being far too close to 'as great a nuisance as can possibly exist in a town'. This was a reference to the factory of Mr Habakkuk in St Mary's Street: 'The dreadful proprietor of this dreadful works' produced soap and 'Habakkuk's Luciferous Transparent Candles'. His business made a bit of a stink, as did the design of the rooms themselves. Thomas Rees in his *Topographical and Historical Description of South Wales* (1810) described them as an 'inelegant and misshapen a pile of buildings as can well be imagined'.

Nevertheless, the Assembly Rooms were the venue for the appointment in 1821 of the Provincial Grand Master of Freemasons in South Wales and were in use for the next forty years for balls, dinners, lectures and concerts. The ground floor was open all day until 10.00 p.m. for meetings, reading newspapers, playing cards and billiards. Sadly, the rooms never really flourished, 'the influx of fashionable strangers during the summer months having been of late years much diminished', *The Cambrian* newspaper reflected mournfully.

The Assembly Rooms were managed by the council, with a tenant responsible for the maintenance and supervision of the building. The first of the tenants was John Harrison, 'Professor of Dancing'. He was soon relieved of his duties for failing to pay

Dancing.

Mr. HARRISON, *Professor of Dancing*,
(From the King's Theatre, Opera-House, London),

RETURNS his most grateful thanks for the distinguished patronage he continues to receive, and respectfully informs his Pupils and Friends, that his ACADEMY Swansea will RE-COMMENCE on Monday, January 29th; particulars of his Circuit in the next Cambrian. Assembly-Rooms, Swansea, Jan. 19, 1827.

Dancing.

Mr. BARREE, Professor of Dancing,
Son and Pupil of Monsieur Barree, from the Opera-House, Paris, and late Ballet Master at the Op & House. London, and Teacher of the celebrated Mademoiselle Parisot),

MOST respectfully begs to announce that he will RE-OPEN his SCHOOLS and ACADEMIES, for DANCING and MUSIC, at Swansea, on Saturday, January 27th.

Private Quadrille Parties on the usual days.
Swansea, January 17th, 1827.

Advertisement from *The Cambrian* newspaper from January 1828. (By kind permission of SWW Media)

his rent – building a stable in the courtyard without permission and unspecified, and intriguing, 'misconduct'. He died in London in 1833.

His local rival, dancing teacher Louis Barree, took over the running of the Assembly Rooms at a rent of £40 per year. He was involved in most of the musical activity in the town. He taught music, his wife taught dancing and he sold pianos from a shop on the High Street. However, his management of the Assembly Rooms ended with a spectacular fall from grace in March 1845.

He was accused of indecently assaulting ten-year-old Julia Probert, one of his piano pupils. She'd been a pupil for around a year. She had gone to the Assembly Rooms in Cambrian Place for her lesson, during the course of which he had started to touch her. In its report, *The Cambrian* spared its readers from the details: 'A portion of the evidence here is too disgusting and utterly unfit for publication.'

When the next pupil arrived, he told Julia to return for another lesson later in the week. Julia said nothing at the time out of fear but eventually told everything to her aunt, Elizabeth Davy. Poor Julia, frightened and confused, said Barree had changed. Before Christmas he had described her as 'a dull and thick-headed mortal', but somehow, and she didn't know how, she had made significant improvement. Since January he had started to call her 'little dear' and had started to touch her.

Sordid details make this a horrible story. To his credit Barree pleaded guilty, which meant that Julia didn't have to appear in the dock. Defence counsel was desperate to mitigate the sentence. They said that he couldn't pay a fine, since the financial position of his family was not flourishing. He had a wife and two children, and if he was driven into debt the family might never escape from the punishment. The judge listened

politely, but was naturally unmoved. He was sentenced to one year's imprisonment in Cardiff gaol. Mrs Barree continued with her Dancing Academy in the Assembly Rooms for a while but later moved out, first to Fisher Street, then Prospect Place and later to Thistleboon in Mumbles. It would seem that she had washed her hands of her husband completely. On his release he emigrated to America, while she stayed behind. He died in New York in May 1851, aged fifty-two.

The Assembly Rooms were now tainted in the resident's minds and, once the docks opened, the area changed completely. The users of the Assembly Rooms fled to the west, away from the centre of the town. It was no longer an area they wished to frequent. It was dark and intimidating. A letter to *The Cambrian*, in June 1853, complained of the total absence of artificial lighting at the entrance and on the staircase. Another letter, in December 1856, said the place was 'in a shabby and disgusting state, unfit for the reception of ladies and gentlemen'.

It became the home of Swansea's School of Drawing and Design, until the opening of the School of Art in Alexandra Road in 1880. The Billiard Room was used as an arsenal for the local Artillery Militia. Since it was close to the docks, shipping companies moved in and for a hundred years it accommodated offices until the closure of the South Dock in 1972. Today, it has been turned into apartments. It is one of very few buildings that remain from the pre-Victorian age, and we see it with nostalgic eyes as simple and elegant – a triumph of the architect William Jernegan, representing a lost dream.

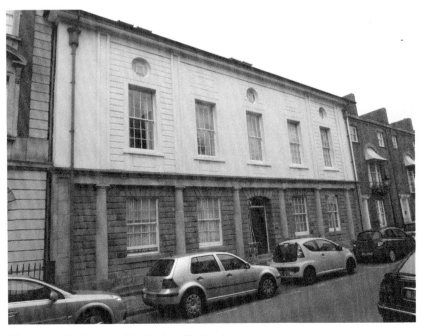

The Assembly Rooms. (Author's collection)

Thomas Bowdler

It is interesting to note that Thomas Bowdler was born at Box near Bath in 1754 and achieved fame in Swansea, while Richard Nash, as we will see, did exactly the opposite. Bowdler is a famous adopted son, in fact he could claim to be the most prominent figure from Swansea's literary history. After all, who else has their very own word in the English language? To Bowdlerise, meaning 'to expurgate' or 'to censor' by removing parts that could be offensive, is a word that was born overlooking Swansea Bay in the early nineteenth century.

He came from a wealthy family and studied medicine at a university in Scotland. He became a Fellow of the Royal Society and a member of the Royal College of Physicians, though he never practiced medicine and spent a great deal of time touring the continent. He was married in 1806, but it was not a happy union and they soon lived apart. In fact, his wife, Elizabeth, was not mentioned in the biography written by Thomas Bowdler's nephew. In 1811, he moved from the Isle of Wight to Rhyddings House in the Uplands, enjoying the expansive views over Swansea Bay until his death in 1825 at the age of seventy. He is buried in All Saints churchyard in Mumbles.

The grave of Thomas Bowdler in All Saints Church, Mumbles. (Author's collection)

The inspiration for his assault upon Shakespeare came when he realised that his father, who had read the plays aloud to the family, had left out passages that he regarded as unsuitable. Why shouldn't all families have such advantages? Ironically, perhaps, much of the work was done initially by his sister Henrietta Maria (or Harriet), who removed from the text 'some defects which diminish their value' and that women should not read. *The Family Shakespeare* was published under her brother's name in 1807 and became extremely popular. The enlarged 1818 edition was a particular success.

This edition contained twenty of Shakespeare's plays that omitted 'whatever is unfit to be read aloud by a gentleman to a company of ladies'. He aimed to produce an edition of the plays that 'would not bring a blush to the most innocent cheek of youth'. Bowdler felt that 'nothing can afford an excuse for profaneness or obscenity', so in *Romeo and Juliet* 'the prick of noon' became 'the point of noon', Lady Macbeth's sleepwalking cry 'out, damned spot! Out' was changed to 'out, crimson spot! Out' and famously in *Hamlet*, Ophelia's suicide became an accidental drowning.

In his final years, Bowdler turned towards the work of the historian Edward Gibbon, and Bowdler's sanitised version of Gibbon's *Decline and Fall of the Roman Empire* was published posthumously in 1826. By 1827, *The Family Shakespeare* had gone into the fifth edition.

Bowdler took an interest in the affairs of Swansea, apparently devoting his time to the 'spiritual and temporal welfare of the inhabitants of Swansea'. You wouldn't have thought there were enough hours in the day: he was a proponent of prison reform, and he wrote to the editor of *The Cambrian* newspaper supporting the creation of savings banks for 'the lower order of the inhabitants' and was a prominent member of the congregation of St Mary's Church. In his will, he bequeathed to St Mary's a painting of the Madonna and Child by the seventeenth-century Italian artist Giovanni Battista Salvi, also known as Sassoferrato: 'My wish is that it may be placed after my death as an Altar-piece in the Chancel.' Sadly, this was destroyed during the air raids in February 1941. However, you can still get an idea of the piece, since Sassoferrato produced multiple copies of his work, and there is one in Amsterdam. He also bequeathed substantial donations to the poor of both Swansea and Box.

Of course, Thomas Bowdler has been much derided. An article in *The Cambrian* in September 1905 by Wilson Crawford accused him of trying to 'make himself immortal by attempting to deodorise The Bard of Avon'. Crawford goes on to say that whether or not the reader can congratulate him on the 'peculiar happiness of having so purified Shakespeare and Gibbon that they no longer ... plant a pang in the heart of the devout Christian, will largely depend, on his view point as to whether one man has the right to ruin the works of an immortal'.

He takes great pleasure in pointing out that the entry on the Elizabethan playwright Thomas Heywood in *Chamber's Cyclopaedia of English Literature* indicates that in *The Fair Maid of the Exchange*, 'the amorous gallant, who is far from careful of delicacy either in speech or deed, is called Bowdler'.

June 1952. (By kind permission of SWW Media)

However, in general, Bowdler had no desire to change Shakespeare substantially; he merely wanted to tone it down, and he possibly brought more people to the plays as a result. The poet Swinburne said, 'No man ever did better service to Shakespeare than the man who made it possible to put him into the hands of intelligent and imaginative children.'

Perhaps, we ought to be grateful. In the late seventeenth century, Nahum Tate rewrote the tragedy of *King Lear* to provide a happy ending. He then turned his attention to *Coriolanus* and next to *Richard II* in which he altered the names of the characters and changed the text so that it was 'full of respect for Majesty'. It seemed to work; he was made Poet Laureate in 1692. David Garrick, the eighteenth-century actor, rewrote Shakespeare too, though he was probably motivated more by ego than any high moral purpose. There was a level of local support for Bowdler. In March 1831, *The Cambrian* published a poem by 'W' called 'Thoughts on the Dead – Elegiac Stanzas written in Oystermouth Churchyard' in which he implies in a section on Bowdler's grave that without his interventions the works involved would not have survived:

> For learning, old and new, was thine,
> And thine the trav'ler's polish'd thought:
> But these, without thy lore divine,
> And trust in God, were now but nought.

Sadly, Thomas Bowdler made it back into the newspaper in June 1952. The roof of his home in the Rhyddings, at the junction of St Alban's Road and Bernard Street, was badly burnt. The house had been repaired after extensive bomb damage in 1941 and was being converted into flats. It was believed that the fire had been caused by 'sparks from a blow lamp being used in removing old paint near the roof, getting into a bird's nest'.

C

Constitution Hill

Constitution Hill is undoubtedly spectacular, rising from Walter Road to Terrace Road and rewarding you with a view described in 1892 as 'the finest prospect in the entire principality'. It is 'a view-point which surpasses all others – one spot from whence may be taken in with one broad sweep of the eyes a grand panoramic picture of local landscape and seascape such as cannot be surpassed'.

The same view still inspires visitors, but in recent years the hill itself has been managed and calmed and is no longer completely accessible to traffic. However, it remains the sort of challenge that attracts all kinds of people eager to test themselves against its steep and unforgiving gradient. It is described as the world's steepest, inhabited, cobbled road and has, bizarrely you might think, an almost legendary status among cyclists. They will tell you, with breathless excitement, that the height difference between the top and bottom is 184 feet (56 m) and that the average gradient is 1 in 6 (17 per cent) with a maximum gradient of 1 in 3 (33 per cent).

This is why you feel tired if you walk up to the top. But not perhaps as tired as those who like the challenge of cycling uphill – a task made even more difficult in Swansea rain, which makes the cobbles vindictively treacherous. Cyclists say that it is one of the 'five UK roads to cycle before you die', though for me the words 'horribly as a result' seem to be missing from the end of that sentence.

Constitution Hill sometimes features in cycle races involving professional riders, some of whom – whisper it softly – have been known to get off and push their bikes when the going gets tough, though not, of course, the great Bradley Wiggins, who crested the hill in front of enthusiastic crowds when it featured in the Tour of Britain in 2010. It is unlikely he had any opportunity to admire the view before the race sped off along Terrace Road and down Mount Pleasant before finishing on the Kingsway. The stage was won by the eventual winner of the Tour, the Swiss rider Michael Albasini.

When it had featured in the 1993 race, the Belgian winner Serge Baguet said that the descent was worse than going up. When it was used in 1999, the Lithuanian cyclist Raimondas Rumsas won the Swansea stage after racing away from his rivals on Constitution Hill. He later retired from cycling after performance-enhancing drugs

Constitution Hill.
(Author's collection)

were found in the back of his wife's car. I hope it wasn't Constitution Hill that tempted him to the dark side.

Its iconic status was emphasised when Constitution Hill was featured in a scene in the strangely popular film *Twin Town*, involving some extreme car action. But there have been others who have been up the hill before. In the early days of motoring, it was a great test to see if you could coax and bully your car up to the top. But descending also has the potential to be pretty tricky. I once drove down the hill clutching the steering wheel in a vice-like grip, which was bad enough, but thankfully I avoided the drama of an incident in August 1904. A group of well-heeled motorists succeeded in getting to the top, but it all went wrong on the way down when their brakes failed.

The four passengers jumped off on the chauffeur's advice and the chauffeur himself turned the car on to a bank. It slid off on to the road again, and turned over with the chauffeur underneath. He had a miraculous escape, and strange to say, the car was so little unhurt that all the occupants were able to drive off in it.

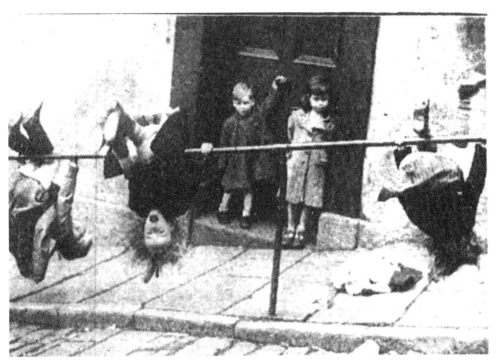

Children on Constitution Hill, in January 1950, waiting for another car to overturn. (By kind permission of SWW Media)

I think the driver had every right to expect a decent tip when they got home. Such incidents still happen. A motorist managed to turn their car upside down after reversing into a lamp post in October 2015.

Motorcyclists enjoyed it too. In March 1914, 'Mr Handel Davies who won a large number of prizes in South Wales last year for hill climbing, successfully negotiated Constitution Hill on his James cycle and side car, carrying two passengers, the three, between them weighing 30 stone.' Plenty of traction there then. Handel Davies went on to use his considerable skills as a dispatch rider during the First World War. Even today people can't leave it alone. In December 2013, a fitness challenge culminated in contestants dragging a tyre up Constitution Hill for the British Heart Foundation, presumably to raise money rather than produce new patients, with the peculiar intention of 'pushing entrants to their physical limits'.

It could be an ideal venue for winter sports, as this item from February 1895 testifies: 'The recent heavy falls of snow have greatly interfered with the skating prospects, although Mount Pleasant Hill and Constitution Hill peculiarly lend themselves to the pastime just now, as those who live on the hill can testify.' It has always had its dangers. In March 1898, 'the lad, John Jones, of Penygralg Road, who sustained concussion of the brain through a fall at the bottom of Constitution Hill, succumbed to his injuries

Tyred out – December 2013. (By kind permission of SWW Media)

at the hospital. The deceased was descending the hill with his hands in his pockets and fell, striking the curbstone'.

To alleviate some of these issues, the Swansea Constitution Hill Incline Tramway operated a cable tramway service on the hill between the lower terminus at St George Street (now Hanover Street) and the upper terminus at Terrace Road. It opened for service on 27 August 1898.

Two counterbalanced cars were fixed to a steel cable, powered from the top of the hill by two gas engines. Sadly, it wasn't a success – probably because it didn't really go anywhere. Receipts were low and costs were high; two crew members had to be paid, along with staff in the winding house. It was also compromised by repeated breakdowns. It closed in 1902 and the lines were removed, at which time it was felt, rather too late you might think, that the line had been constructed on the wrong hill, and that it should have been built on Mount Pleasant instead.

D

Dunvant Explosion

The Dunvant Explosion of November 1902 is a fearful story, and its origins lie not only in carelessness and human frailty but also in the casual acceptance of dangerous working practices. The story is here to represent the grim catalogue of industrial accidents that lies in a thick seam of horror through our history: men crushed between trains, men falling into vats of molten copper, men struck by flying metal. There were explosions in the Beaufort Colliery in 1867, in Hendrefoilan in 1869, in Llansamlet in 1870 and in the house of William Jenkins in Dunvant in 1902.

William Jenkins worked as a cutter at the coal face in Caerbryn Colliery near Llandybie near Ammanford. He stayed there in lodgings and came home to Dunvant at weekends to his wife Sarah and their three children in their four-roomed cottage at Cross Roads. He was thirty-two, and she was thirty-three.

The explosion happened at 9.30 p.m. on Saturday 8 November, 1902. William had returned from work, and he and Sarah were in the living room with their three-year-old-son John, on a settle beside the fire. The other two children, nine-year-old Isaac and seven-year-old Mary Ann, were asleep upstairs.

It was an event of 'fearful violence', and the house was effectively dismantled. A large piece of the wall behind the fire was blown out and hurled several yards into the garden; internal walls collapsed and masonry was scattered everywhere – some of the bricks were over 12 yards away from the house. The external walls were forced out by 6 inches, and the one at the back was cracked up to the slates. There was a strong smell of gunpowder everywhere.

William staggered outside but immediately realised that Sarah and the children were trapped inside. He was a mass of flames. Neighbours managed to extinguish the fires that were consuming him, but he broke away from them to try to smash his way through the kitchen windows with his bare fists, 'the dried blood on the sash tells how dauntlessly he laboured'. The window panes were too small, so he rushed to the parlour window where he succeeded in breaking the sash, though he cut his hands badly. As he cried out in grief for his children, Sarah emerged carrying John, with her clothes burning. There were several burns on the child's head, face, arms and chest.

Author's collection.

William caught Isaac and Mary, who threw themselves from the smoke-filled bedroom. Doctors were called. William's injuries were dreadful and the *Evening Express* reported: 'It speaks volumes for the heroic fortitude of Jenkins and the terrible suffering under which he saved his family, that when his arms were dressed, skin and flesh peeled away to the finger tips.' Sarah took John to a neighbour's house and held him close to her in bed until he died at 4.45 a.m. The distraught parents were taken to Swansea Hospital with severe burns and, in William's case, with severe lacerations.

He was suffering considerably from shock, though Sarah's injuries were more extensive. William died from his injuries on Wednesday morning and Sarah died on Thursday afternoon. Tragically, on the day before her own death, Sarah gave birth prematurely to a stillborn child.

Before he died, William said that the explosion had been caused by 'compressed powder' that exploded, and it soon became clear that he had brought explosives home with him from the mine. Suddenly, there was possible cause and effect. Perhaps he had put his box too close to the fire. Perhaps there had been a spark or a crackle. But why had he brought explosives home in a box?

It was quite simple. One of the rules of Caerbryn Colliery was that coal cutters should provide their own blasting material at work. It was said that, in many collieries, this was standard practice. Investigations showed that William and his workmate Daniel shared the cost of the explosive reels they had bought at a licensed store in Penygroes. Daniel said William had five reels left in his tin when he went home on Saturday. He usually kept the box in an outhouse at his lodgings, taking sufficient explosive for the day when he went to work in the morning, but for some reason this time he had taken it back to Dunvant. Perhaps he was keen to get back to his family and didn't want to be delayed by putting it away. Perhaps he was concerned someone might steal it if it was left in the outhouse. Who can say? He was certainly not authorised to keep blasting powder of any kind in his house. Why should he?

To anyone else, such as the coroner, it was a completely absurd practice. But to miners who were keen to increase their productivity by using explosives as an alternative to hacking away at the coal face with a pick, it seemed a convenient way of boosting their earnings. But it also meant that miners were often carrying gunpowder around with them through the streets.

Thomas Morgan, the manager of the Caerbryn Colliery, confirmed that there was only one type of explosive permitted, which the miners could buy for themselves at a licensed store around a mile from the colliery. Every charge was examined by the shotfirer, ensuring that no other explosive material could be used. In the world in which he lived, this seemed an entirely reasonable behaviour.

It was not a view that was widely shared. The coroner said the tragedy happened because William had stupidly taken gunpowder home instead of leaving it in the outhouse, but it was a ridiculous system for miners to buy their own explosives. It was a most dangerous practice, and he felt obliged to bring it to the notice of the Home Office. The jury returned a verdict of accidental death and strongly condemned the practice of keeping explosives in or near dwellings, adding a recommendation:

> That all colliery proprietors should be compelled by law to provide a magazine for each colliery where any explosive is used for the storage thereof, and that such explosives should be obtained by those using it direct from such magazine, and that intimation to this effect be sent by the coroner to the Home Office and Mr. Robson his Majesty's inspector of mines for the district.

Mock health and safety if you will, but this was a sensible, obvious recommendation, though much too late.

Dear Editor

The residents of Swansea have written many letters to the local press over the centuries. There has been so much to complain about after all. Naturally, most of the letters were written by older male residents, eager to confirm their proud transformation into grumpy old men. They fired off letters about 'how Swansea young men waste their lives', about 'drink and profligacy', about how 'fashions seem to have become more grotesque than ever'. Trust me, it makes you feel good.

They were never happy ratepayers, although their lives would have been dreary without the council to complain about. And complain they did. For example, in 1881, a shelter for cabmen was erected in Castle Square, which horrified 'heavily-taxed ratepayers'. It was the 'ungentlemanly language of cabbies and the effluvia arising from the standing of the horses' that did it, things that you might regard as the inevitable consequences of such a shelter.

They always wanted to know what their rates were being spent on, but as far as they were concerned it was never the roads. In March 1836, a letter observed that 'Wind-street is a disgrace to any civilized community and if the principal street in the town is

neglected, what shall we say of the back streets? Why, some of them would disgrace a Portuguese village.' In 1876, a resident declared,

> I am fast coming to the conclusion that civilisation is a failure, that we would be better off in our original state of wildness. Look at the state of our streets and footpaths after one day's rain ... we must, at the lower end of Hafod-street, make our way through a frightful amount of mud and dirt before we get fairly on the Strand.

I think I'd rather be in Portugal to be honest.

However, it didn't get any better. In 1885, Mr Nancarrow of St Thomas raged, 'For the last three days the roads have been inches deep with mud, and this is not at all exceptional.' A year later we are told that 'in the heart of the town there are places without pavement at all which are discreditable to us as a community and most objectionable to pedestrians.'

One of the consequences of badly maintained streets was the easy availability of stones, and stone throwing was another source of anger. In 1870, a group of boys threw stones at the windows of Vincent Street School with such enthusiasm that the teachers were trapped inside and had to be rescued by the police. But they were the lucky ones, because apparently you could never find a policeman when you needed one.

In October 1876, a letter called 'Where are the Police?' revealed:

> There happens to be a chestnut tree in the corner of my garden, and the damage, annoyance, and danger we are subject to from youths of the neighbourhood pelting stones at the nuts is very great. If a Policeman was seen here now and then there would be a chance of frightening them, but it is a rare thing to see one of the police this way.

In 1882, it was observed that:

By kind permission of SWW Media.

THE STATE OF OUR STREETS.

TO THE EDITOR OF "THE CAMBRIAN."

SIR,—Will you allow me, through your valuable medium, to call the attention of the authorities of this town to the state of the upper part of the Strand, Elephant Lane, and the access to Hafod-street, through that part lying between Bethany school-room and a portion of the premises of Mr. White. I think a little investigation in this matter would end in bringing the members of our municipal body to the same opinion the inhabitants of that locality hold, viz., that it is not in the condition it ought to be.

That neighbourhood is thickly populated, and for a long time these people have been paying according to the position and class of houses, high rentals, and, o course, directly or indirectly, a due proportion of rates and taxes ; they therefore feel that they have a right to expect that their roads and pathways should be somewhat in order (especially after scores of private individuals have been ordered to pay 6s. costs for not sweeping the pavements), and they also feel that the portion of the town mentioned has not received the attention it needs.

stone throwing prevails to a much greater extent in Swansea than those who live in the well-ordered districts believe or can imagine. On the Townhill, at Dyfatty, at Greenhill and other places where the rougher sort of boys congregate and where the abundance of loose stones be readily to hand, it is frequently quite dangerous to pass along the public roads.

In 1888, *Pedestrian* complained about 'the annoying and dangerous practice' of stone throwing,

which is working much harm as well as terror among timid people. On Sunday evening as I was walking home from church through Singleton Street, a little gang of boys threw several stones at me, two of which struck me on the side, one of the missiles taking me on the upturned coat-collar just below the ear. Of course there was no policeman near.

The issue emerged again in 1916 when a letter reported that three boys, who were caught throwing stones, received a good 'lamming' from their parents. There were other issues too. In October 1893, a correspondent wrote, 'a timely word of warning' about the behaviour of young people on public transport:

I was much surprised and disgusted the other day, when riding on the Mumbles Railway to note the behaviour of some fifteen or twenty boys and girls of school age. They were no sooner mounted than they began, girls as well as boys, to indulge in laughter and teasing, and provocation, and rough and tumble play. I noticed that one of the civil and obliging young guards or ticket collectors in the employ of the Company, climbed to the top of the carriage and endeavoured to impose order and decency among the youngsters ... But, try as he would, he could not get the youngsters to behave themselves, and so had to give up the task in despair. I am told that these youngsters are the children of parents residing at the Mumbles, and are sent up to town daily to attend school.

In February 1881, a letter of complaint was received about behaviour on the streets. Young people, it seems, had

no hesitation about pushing you into the intolerably dirty streets, and use language (not always in Welsh) that is simply a disgrace to a town possessing such a number of Chapels ... footpaths seem to be made especially in some parts for the convenience and sole accommodation of men and boys, whose occupation appears to consist of chewing or smoking tobacco, the fumes from which would stifle a gorilla, the juice from which they freely bestow on the clothes of the passers-by.

Nice. And what do we find in the *Evening Post* in November 1957? A letter about youths who gather 'in small noisy bitter groups around the lamp-posts at night' and cause a nuisance.
Does any of this sound familiar?

Frederick Higginson

During a remarkable career, Wing Commander Frederick Higginson OBE, DFC, DFM (1913–2003), as Swansea's finest fighter pilot, managed to turn a *Boy's Own* adventure into an almost unbelievable reality.

He was a policeman's son, born in Gorseinon, and a pupil at Gowerton Grammar School. He joined the Royal Air Force (RAF) as an apprentice in 1929 and became a pilot at a crucial time in our history. Higginson first saw action at Dunkirk in 1940,

Frederick Higginson's grave in the Church of Mary Magdalene, St Clears. (Author's collection)

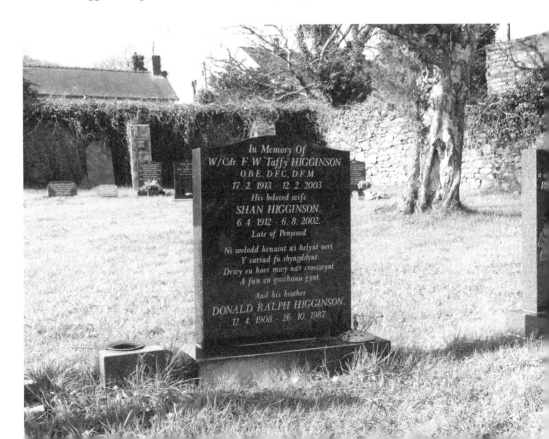

and by the time of the Battle of Britain he had shot down fifteen enemy aircraft and had been awarded the DFM. However, his luck ran out in June 1941, when his Hurricane fighter was shot down near St Omer in northern France. He was picked up by a German officer and a sergeant, who stuffed their prize capture into the sidecar of the motorcycle they were riding. In true comic-book style, they probably said something like, 'For you zee war izz over.' It wasn't.

Their attention was drawn by a low-flying Messerschmitt and, like boys everywhere, they stopped and watched it with pride and envy. While they were thus distracted, Higginson, continuing the comic-book theme, grabbed hold of the handlebars, tipped the motorcycle into a ditch and then ran off into the woods, leaving his captors waving their legs in the air in an undignified way.

The next fifteen months were nothing if not bizarre; although, they started off quite sensibly. He was picked up by the Resistance who took him to the man they knew as Captain Paul Cole, left behind after the evacuation of Dunkirk, and now part of an escape network for downed airmen. Cole took him to Abbé Carpentier, a priest in Abbeville, who provided Higginson with false identity papers. Higginson travelled to Paris, where he hid in a brothel for a few weeks until Cole escorted him by train to Vichy France, which the Germans technically had not occupied, from where they hoped he could escape to the UK.

When they were questioned by German border control, Cole's explanation that Higginson was an idiot seeking work was surprisingly unconvincing, and they searched his case. However, the contents were smothered in chocolate that had melted in the summer heat, and their search was cursory. Once they were across the border, Higginson went straight to a safe house in Marseilles, and Cole returned to the north.

It is in keeping with the rest of this story that Cole was not a stranded army captain at all. He was a sergeant who had absconded with mess funds. Later, when captured by the German soldiers, Cole betrayed a number of Resistance figures, including Abbé Carpentier, who was subsequently executed.

On 4 July 1942, Higginson caught a train to Perpignan, but his attempt to cross the Spanish border was thwarted when he was stopped by gendarmes. Higginson, in his frustration, thumped one of them. This was a mistake. He was so close to escaping, but was now imprisoned for six months for having false papers and was then, as an imprisoned soldier, moved to Monte Carlo. During this time his weight fell from eleven to seven stones.

The RAF was very keen to get a valuable resource such as Higginson back, and so a Polish priest and British agent called Father Myrda smuggled a hacksaw blade into the prison. Given his weight loss, we must presume that it wasn't hidden inside a cake. On the night of 6 August 1942, Higginson and four other pilots escaped down a coal chute and then through a sewer during a prisoners' noisy concert performance created as a diversionary tactic. The Resistance provided him with a cassock and, therefore, disguised as a priest he was taken first to Marseilles and then on to what

is now the popular beach resort of Canet Plage near Perpignan, where he was picked up from the beach by a dingy and then transferred to a patrol boat that took him to Gibraltar. Finally, he was flown home to RAF Greenock on 5 October 1942.

Naturally, Frederick Higginson's war was not over. He rejoined his old squadron, and further combat successes, frequently as squadron leader, led to the award of the DFC. The citation indicates that his skills were undiminished: 'He has now destroyed at least twelve enemy aircraft and throughout has displayed great skill and courage in combat with the enemy.'

After the war, he was involved in pilot training programmes and was promoted to wing commander, before establishing a successful civilian career as a director for British Aerospace in the guided weapons division. His work in developing overseas markets for missiles was recognised with an OBE in 1964. He never lost contact with his past and always retained a respect for the German pilots who had once tried to shoot him down.

In 1969, he retired to a farm in St Clears, where he lived with his wife Jenny 'Shan' Jenkins, whom he had married in 1937, and their four sons. Shan died in August 2002 and Frederick followed her on 12 February 2003. He was almost ninety years of age and was honoured at his funeral in St Mary Magdalene Church in St Clears by an RAF fly-past.

It is a remarkable story of courage, determination, and not a little good fortune, but it is one from Swansea's rich history that deserves greater recognition. After all, in the first days of the war, the British government's planners estimated that the average life expectancy of fighter pilots would be three weeks. Frederick Higginson from Gorseinon exceeded that by a considerable margin. The children of Gowerton School, where there is a plaque in his honour, would do well to remember him.

By kind permission of SWW Media.

Funeral sees aerial tribute to Battle of Britain hero who died aged 89

Sky salute send-off for ace's final flight

By Chris Davies

Fforestfach Show of 1909

Fforestfach has a history that is hidden beneath the skin of our everyday world. There was a highly significant battle in Cadle in AD 970 between rival Welsh princes – the details of which have slipped from collective memory – but the legacy of that brutal confrontation is still there in the names we use every day. Cadle itself means 'place of battle', Penllergaer means 'the head of the camp' and Killay, further away of course, 'the place of retreat'. In fact, the area had a history long before Swansea did. The old Roman road heading to the west is beneath the surface now too, though its outline is clearly visible along Middle Road.

Fforestfach developed in the nineteenth century, as Swansea expanded and people came to serve the industries. The collieries, brickworks at Cwmdu and the railway through Cockett all needed workers, and the town slowly drew the area into its embrace. It has remained a place where the city meets the countryside and where farms and gardens and allotments have always been important.

In the summer of 1909, the second annual show of the Fforestfach Agriculture and Cottage Garden Society was held. Sir John and Lady Llewelyn turned up to bring dignity to the occasion, and 3,000 spectators were present to make up the crowd. They enjoyed the excitement of judging horses, dogs, pigeons and poultry and presumably gasped with astonishment, when D. Jones of Killay won the prize for the best mangold. But the mood on that bright day in early August was suddenly destroyed because a child was killed.

The crowd had gathered around the display ring for the judging of the best-presented tradesman's horse and wagon – a competition that included a team belonging to W. G. Lloyd, a removals man from Landore. The driver was William Leach, and he ensured that the horse trotted happily round the ring, pulling a heavy wagon. On its second circuit, however, it made a sudden dash for the exit and ploughed into the crowd. Spectators were thrown in all directions and some were trapped beneath the wagon. It was a scene of terrible confusion: 'Shrieks rent the air, and there was such a rush to the scene that it took several policemen all their time to keep the excited surging crowd off the struggling people on the ground' (*The Cambrian*). Others could not get away from the scene. Consequently, attempts to rescue those trapped were hampered.

The horse was quickly brought to a standstill by Mr S. Snell of Ffynone Lodge, who grabbed the reins when it was on top of at least fifteen people: 'It was fortunate this was so, for had it been allowed to get any further many more people must have been injured.'

When the accident happened, another competition was just finishing – the competition for ambulance work – and the team led by Dr Frazer had just won a prize:

> Thus there was a band of willing and skilful helpers ready at hand, and unfortunately there was work on which they could test the value of their teaching. These, with five other squads rushed to the scene, and quickly they were administering to the requirements of the sufferers.

Eighteen-year-old John Jones from Tycoch had been knocked unconscious and a wheel ran over his leg, though he suffered no broken bones. Others, however, were not so lucky, and the Mainwaring family of Fforestfach suffered considerably.

Seven-year-old Annie May Mainwaring had been leaning on the rope around the display ring when she was trampled by the horse. The base of her skull was fractured. She was carried half-a-mile away to Dr Frazier's surgery but died there within thirty minutes. She had been badly crushed by either the horse or the wagon. Her grandfather Robert suffered an injury to his knee, her grandmother was wounded on the arm and leg, her three-year-old-sister Rachel sustained a fractured thigh, and her brother had injuries to the arm. Several others were also injured, including a woman who sustained serious mouth injuries.

You will be impressed to hear that 'when order had been restored and the injured were removed the judging was resumed, and the proceedings carried on to the finish'. Such fortitude.

At the inquest held the following day, William Leach declared that the horse had been frightened by the band that was playing. He tried to control the startled animal, but when his foot slipped he dropped the reins accidentally and before he knew it, the horse was out of control. Police Sergeant Thomas from Sketty said the band was not playing when the accident happened. Others maintained that they had seen Leach use his whip before the incident.

The owner of the horse, William Lloyd, couldn't understand what had happened and spoke highly of the creature, saying that it was normally very quiet. He also spoke in support of Leach, who had been driving horses for twenty years and had been a total abstainer for fourteen of them. On reflection, he did not think he could have done anything other than what he did under the circumstances.

It is interesting that the coroner, delivering a verdict that surely would never be delivered today, said the accident was a very deplorable one, but there was nothing that indicated culpable negligence. The evidence showed that the driver did all he could and a verdict of accidental death was returned.

In response to the tragedy, the committee for the Gower Show, which met a few days later, discussed the need to take out insurance cover for themselves and Swansea District Council examined the incident briefly later in the month. They felt that the accident was the result of inadequate preparations, 'for the access and egress from the field' was very poor. Their view was that the accident was preventable and that responsibility lay with the managing committee of the show. No action, however, was taken.

In 1917, the show was revived and held in Gendros by the Fforestfach Allotment and Cottage Garden Food Production Society. You will be as pleased as I was to learn that the winner of the *Best Collection of Vegetables* was R. Phillips of Loughor. The prize was donated by H. A. Leak of Oxford Street.

Author's collection.

G

Ghosts

Swansea has never been a particularly fertile ground for ghost hunters. It is an odd enough place as it is, without the thoughtful assistance of the supernatural. But if we must examine spooks, let's start with the legendary actor Edmund Kean, who spent some time in Swansea in 1809 and was persuaded, for a wager, to spend the night in a haunted room in Oystermouth Castle. Inevitably, at midnight the ghost appeared dressed in white and rattling chains. In response, Keen produced a rapier and rushed towards the apparition, which screamed loudly and had to be rescued by pals lurking outside. Sadly, this simple idea of throwing a sheet over your head and pretending to be a ghost was, for a while, the funniest joke ever to hit Swansea.

In March 1849, beer-shop owner John Huxtable tried to intimidate his rival, the landlady of the Sawyer's Arms on James Street, and drive away her customers. He sent his wife to parade up and down outside the Sawyer's Arms at midnight with her gown turned over her head, apparently like a ghost. The magistrates dismissed the case and told the landlady to pull herself together. Today, of course, the mere suggestion of a ghost would have paranormal investigators and drinkers queuing up outside.

The Sketty Ghost of 1855 terrified an ageing one-armed veteran of the Peninsular War, who fainted in the Toll House and unsettled two young girls so much that when they were running away 'their white undergarments were allowed to have great prominence'. Racy.

After a lot of unnecessary excitement, it all came to an inevitable conclusion when a labourer called Thomas Thomas, described as a 'thick-headed country bumpkin in a snowy-white smock frock', confessed to being the Sketty ghost after his arrest for being drunk and disorderly in Oxford Street. He was fined 5s with 3s 6d costs.

In December 1880, there was a story, readily believed it would seem, of a huge monster spotted at Overton in Gower. At Crow Tor on the road to Paviland, a local youth cornered it in a field and wrestled it briefly to the ground before it escaped. The next morning, a notice was pinned up in Overton: 'Any person anyway molesting me will be in great peril. (Signed) Ghost.' Your naturally suspicious nature might be aroused – justifiably I think – by this helpful advice, but it caused some alarm in south Gower.

'Who looked so fine at first but left looking just like a ghost.' (Bob Dylan – from 'Just like Tom Thumb's Blues.') Original art by Jason O'Brien. (By kind permission)

However, it was a hoax. Honestly. A letter to *The Cambrian* from one of the perpetrators indicated that a young sailor had recently bought a new waterproof coat with a hood from the village tailor. He had foolishly suggested that he could be mistaken for a ghost in it. Enough said. Together with a friend they had concocted the wrestling drama. Very funny. How we laughed. However, the following week there was another letter. The boys didn't know what they were talking about. The apparition predated the purchase of the coat. There was truly an evil spirit loose in Gower. Exasperated, *The Cambrian* ended all correspondence on the subject.

Perhaps the idea resurfaced in 1887 during the case of the Caswell Road ghost – a figure dressed in white that seemed to glide along just above the ground. He was eventually chased and cornered by a sprinting vicar and shown to be a local boy dressed in a long coat with a hood.

Of course, we must not forget the visitation by a spirit dressed in white, which appeared in Mumbles the following year, where it 'frightened a sickly woman into

fits. This kind of practical joke is very stale', said the newspaper. It then moved on to Townhill, before transforming itself into a goblin at the railway station.

However, not all ghost stories in Swansea involve people in big clothes. In the early part of the nineteenth century, Geoffrey Fallet committed suicide and, according to custom, was buried at night at a crossroads – in this case, at the junction where High Street, Castle Street, College Street and Welcome Lane meet. Strangely, even in such a prime location, he did not find peace and so his ghost haunted the crossroads. After a while, in order to release the area from the curse of his apparition, his body was dug up and reinterred on the beach at Sandfields. Thus, when brass knockers were wrenched off doors and later found on Geoffrey's grave, this clearly reflected his resentment at the disturbance of his remains.

Chillingly convincing you will agree, except that the most virulent form of youth annoyance during the nineteenth century was the removal of door knockers. And you have to put them somewhere.

Then there was the York Street ghost who materialised in order to indicate to the residents where her pet dog was buried, which to me seems to involve a disproportionate amount of effort. By 1899 the ghost of Henry O'Neill, who brutally murdered his wife before drowning himself in the canal, was believed to be haunting their old house on Powell Street. Neighbours saw his spirit walking at night in the garden near where his wife's clothes had been buried. He was seen peering through windows and laying clammy hands on the faces of women fetching in their washing. A brave ghost indeed. The newspaper's wise advice was to 'bring a little common sense to bear on the subject'.

In general, most Swansea ghost stories come from the outer limits – Swansea west and Gower. Things have always been a little different on the east side. The evil figure appearing mysteriously out of the toxic fog, dressed in rags with wild, staring eyes, was most likely your neighbour returning after the late shift. Paranormal speculation has never been a staple of eastside conversation. There are exceptions, of course. In May 1908, a Plasmarl school teacher was out walking when an apparition, 'attired in white raiment, floated out of the depths of the quarry'. He was subsequently gripped by incurable fright, a state that today's teachers usually experience on lunch duty. Thankfully, the brick-shifting poltergeist of the Hafod Copper Works, who created a bit of a stir, was shown to be an incompetent employee moving the wrong stuff.

The best spectres I can offer you from the twentieth century are a White Lady floating around in Oystermouth Castle and a dancer that drowned in the *Titanic*, who for some reason now haunts the Grand Theatre. But it is the peculiar sighting of ghostly koala bears on the roads around Llangennith, during the 1990s, that is the hardest to remove from your mind. Personally, I would find any koala in Llangennith, ghostly or otherwise, a little unsettling. In addition, a motorist on the same roads reported driving into a woman in white early in the morning, who stepped out in front of him and then vanished. It seems obvious that she wanted a lift back to Oystermouth. Or she was looking for those pesky koalas.

Peter Ham

At last, Swansea has started to remember Peter Ham. A blue plaque at High Street Station was unveiled on 27 April 2013 and now there is a gravestone, erected in Morriston Cemetery by his devoted fans, almost forty years after his death in 1975.

Peter Ham's memory lives on, but his group Badfinger are remembered not just for their music. For some, they are more famous for their disintegration and their tragedy. Theirs is a cautionary tale: a story of how the idealism of youth can be manipulated and abused by their cynical elders. Rock and roll doesn't rule the world. It never did. Accountants do.

Peter William Ham was born on 27 April 1947 in Mayhill, where, perhaps unsurprisingly, he was known as 'Piggy'. Always musical, playing first the harmonica and then the guitar, he had dreams. His group was initially The Panthers, then The Wild Ones and then The Iveys, named after Ivey Place in Swansea. When they appeared at the Regal Ballroom in Ammanford they were approached by Bill Collins, a manager who wanted to take them on. He moved the band to London, where Tommy Evans joined the group and then, at the end of 1967, The Iveys were offered a recording contract by The Beatles' Apple label. They changed their name again, this time to Badfinger, which was apparently based on an alternate title for the song 'With a Little Help from My Friends'.

Paul McCartney took them into the studio to record one of his own songs. Suddenly they had made it. 'Come and Get It' was a hit across Europe and, most importantly, in America. They would not have recognised the great irony in their first hit in which Paul McCartney expressed his bitterness about the financial confusion of the Apple Corporation: 'If you want it, here it is, come and get it but you better hurry 'cos its going fast'. If ever one song could come to encapsulate an entire career, it was this one.

The defining moment came quite unexpectedly in all this excitement. The group needed a financial manager for their forthcoming American tour. So in 1970, Badfinger enlisted a New York business manager named Stan Polley. He was highly recommended, and Peter and the rest had little reason to doubt him. However, it was rumoured that he had well-established connections with organised crime and

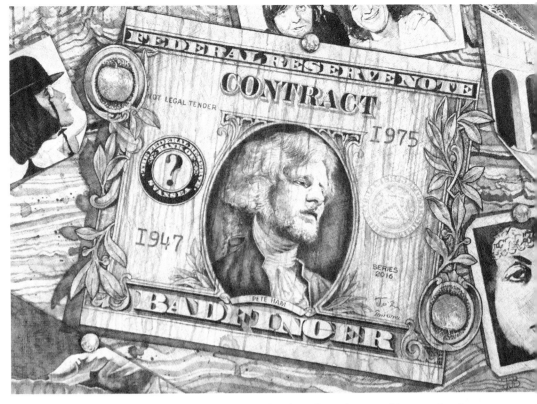

The colour drains from a worthless contract – not legal tender – decorated in a tangle of ivy with apples that invert. It is surrounded by images from Badfinger's albums. And at the heart of it all, a trapped Peter Ham is unable to break free. Original art by Jason O'Brien. (By kind permission)

a facility for complex and dubious financial arrangements. They would soon learn about this at a considerable cost.

Their music was changing. Badfinger developed a harder edge, a more progressive sound, and they found themselves tuned perfectly into the spirit of the times. Their album *No Dice*, recorded in 1970, was very well received. They might not have been 'the new Beatles' as some claimed, but they were good and we liked them. Their music was infectious and well crafted. Peter Ham was writing his finest material and composed the band's biggest-selling single to date, 'No Matter What'.

There was also a song on the album that unexpectedly became a phenomenon. The American singer Harry Nilsson heard *No Dice* and issued his version of the Ham/Evans composition, 'Without You'. It was an international success, recorded by so many different people and in so many different ways. That one song should have guaranteed a prosperous future, sufficient perhaps to retire upon. But I guess it's not the way the story goes.

Badfinger were stars in name, but in reality they remained financially destitute. The band had made a lot of money, but nobody knew where it was. The more famous they became, the more impoverished they appeared. The young boys made the music, but the older men made the money.

In 1972, Polley moved Badfinger to Warner Brother Records for a reputed $3 million. The question has always been: what happened to it? It was a good deal for someone, but it put huge strains upon the group. They had finished their commitments to Apple with an album called *Ass*. On the album cover, they represented themselves as a donkey, following a carrot on a stick representing the promises of Polley.

This new contract meant they had to produce another album for Warner Brothers immediately which was a huge strain. The lyrics of their songs began to reflect their growing despair, 'We're the pawns in someone else's game', wrote Peter Ham. In a song called 'Hey Mr. Manager', Tom Evans said, 'You're messing up my life'. And in 'Rock'n'Roll Contract', Tom wrote again about Stan Polley, 'You made me your slave'. For the sleeve of this ultimately unreleased album, Tom wanted to portray the group being eaten alive by Stan Polley.

In 1975, Warners discovered that $600,000 of their money in a shared account with Badfinger had disappeared and thus refused to market their work, threatening them with breach of contract. Nobody in the band knew where the money had gone, but it had been filtered from the account by the American management company. Their business and musical affairs were now in a state of collapse. Peter Ham couldn't pay his phone bill.

Suddenly, they found themselves dealing with a weasel world for which nothing in their ordinary lives had ever prepared them: contracts, lawyers, obligations, and, of course, big cheques that they never saw.

Peter Ham had written three million-selling singles, had toured America six times, had songs covered by innumerable artists and had co-written a song generally considered a standard; yet, he was penniless.

On the evening of 23 April 1975, he walked into his garage studio, put a rope around a joist and hanged himself. He wasn't quite twenty-eight years old. Peter Ham was survived by his girlfriend Anne and daughter Petera, who was born one month after his death. His suicide note, addressed to his girlfriend and her son, ended with the words, 'Stan Polley is a soulless bastard. I will take him with me.'

Badfinger disbanded after Ham's death, but the lawsuits and bankruptcies didn't cease on either side of the Atlantic. There was still money to be made out of Badfinger, but only by the lawyers. By 1977, Tom Evans was working as a plumber. Band members occasionally tried to revive the group, and at one point there were two rival bands, both called Badfinger. The glory days had gone, but tragedy wouldn't leave the band alone.

On 19 November 1983, Evans argued on the telephone about royalties for 'Without You'. He then hanged himself in his garden:

> I guess that's just the way the story goes.
> You always smile, but in your eyes your sorrow shows,
> Yes it shows.

Ilston

The beautiful village of Ilston is one of my favourite places – a hidden joy of Gower. The Ilston Cwm runs south to the sea and on its banks you will find the impressive St Illtyd's Church – a perfect imagining of a country church. It is first mentioned in 1119, and for a time it was the responsibility of the Knights Hospitaller. Ilston certainly has a long history; a hoard of Roman coins was discovered, and there was probably a monastic cell too. I can also tell you that, in 1832, William Jenkins was fined for cutting down an oak tree belonging to the Duke of Beaufort, and a year later Benjamin John was convicted for using snares to kill hares. I know you will be as shocked as I was to learn that, in August 1907, Police Sergeant Lewis from Gowerton was thrown from his bicycle in Ilston and suffered injuries to his face and body. He made it home thoguh – they bred 'em tough in those days

However, these were not the only important things that have ever happened in Ilston. Ilston Valley plays a significant part in ecclesiastical history, as the home of the first Baptist congregation in Wales, which then reached out across the Atlantic to the North American colonies.

The Baptist movement grew quickly during the 1640s. It maintained that the baptism of a child was pointless, since it could neither understand nor give informed consent to the process. Believers should therefore be baptised as adults, consciously choosing to enter the church. Congregations were organised on a democratic basis, electing their ministers or elders. They promoted the complete separation of Church and State and regarded dancing as a sin, along with all the usual suspects, of course.

Baptists gained influence in Ilston following an Act of Parliament that granted congregations the power to replace their clergymen if they were 'delinquent, scandalous, malignant, or non-resident'. The people of Ilston were dissatisfied with their priest, the Royalist William Houghton, and in 1649 they replaced him with the Parliamentarian sympathiser John Myles from Hereford, who had been at Oxford with the Sheriff of Glamorganshire. At the time, strict conformity to the Church of England was not required and so Myles was able to decide the nature of his church. So Ilston became a funded, established church that was run as a baptist chapel by people who referred to the place as their 'Meeting House'.

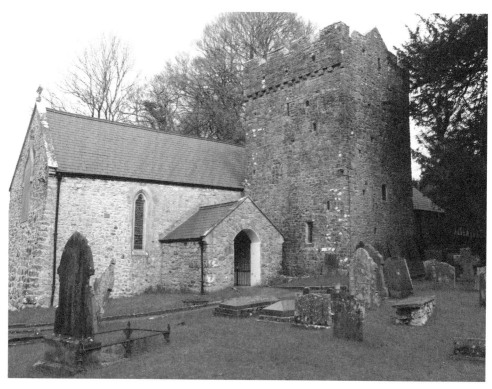

St Illtyd's Church, Ilston. (Author's collection)

The chance survival of the 'Ilston Churchbook', now held in America, tells us much about the congregation. This record of the day-to-day activity of the church shows that Myles was disappointed that his first two converts were women, though he found consolation by persuading himself that God was 'thereby teaching us not to despise the day of small things'. Within a year, Myles had baptised his fiftieth member and the last one recorded in the church book occurred in August 1660, when there were 250 members. Myles observed that 'it pleased the Lord to choose this dark corner to place His name in, and honour us, undeserving creatures, with the happiness of being the first in all these parts among whom was proclaimed the glorious ordinance of Baptism'. Ilston Parish Church remained Baptist until the Restoration.

The congregation was scattered across Gower as a whole, so they didn't all gather at Ilston every Sunday. Sometimes they met locally in members' houses. However, serious matters were referred to the full Ilston meetings which dealt with the baptism of new members, marital advice and questions of discipline. A small number of members were expelled for drunkenness and sexual misconduct. Well, it was Gower after all. Reassuringly, there is no mention of dancing.

Under Myles' influence, other Baptist churches were founded elsewhere in Wales. However, with the Restoration of Charles II, he was ejected from Ilston and William

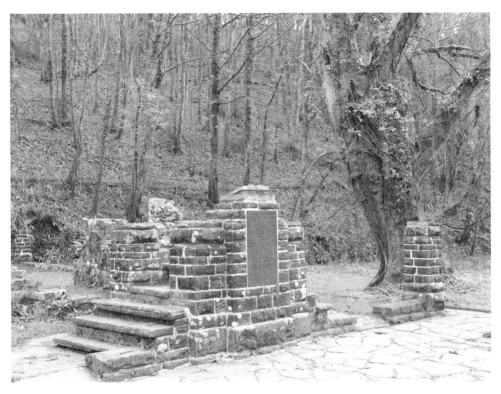

Trinity Well Chapel. (Author's collection)

Houghton returned. It has been suggested that while Myles was in Ilston, Houghton may have conducted his own services in the ruined Trinity Chapel that lies south of Ilston on the banks of the Cwm. It is a lovely walk down along the river, but if you want a shorter stroll you can reach the ruins by walking up from Parkmill. They are certainly worth a visit.

The history of the ruins is unclear, though they seem to date from the late Middle Ages when the chapel was probably built in honour of the well. It is said that Myles and the Baptists used the site as their meeting house after 1660, when they had been prevented from using Ilston. In June 1928, Lloyd George unveiled a memorial commemorating the alleged Baptist association with the site.

Soon Myles and several of his colleagues emigrated to Rehoboth, Massachusetts, where they founded its first Baptist church. The relationship between Myles and the established Puritan Church of Rehoboth was fragile, and he was expelled from the settlement in 1667 for holding unauthorised religious meetings. He founded a new town, which he named Swansey and served as its first minister and schoolmaster. It was the site of the first bloodshed in the brutal King Philip's War (1675–78) between Native Americans and European settlers. Wampanoag warriors laid siege to Swansey for five days before destroying it completely on 25 June 1675. Myles took refuge in

Boston before returning to the rebuilt town, where he spent his last years teaching and preaching. He died there in February 1684.

In Ilston, the remaining members of his Baptist congregation, regarded as dangerous fanatics, were scattered or forced underground by the Conventicle Act of 1664, which forbade religious assemblies of more than five people, other than those of the Church of England. The Baptists and other Protestant Nonconformists did not enjoy religious freedom until 1689. Swansea and Wales became a home of revived Baptism, but Ilston never recovered its importance and returned to welcome obscurity. The Ilston church book, though, was quite another matter. It provides a unique insight into such an important time in English history and was a much sought-after volume. In 1903, the Corwen Historical Society in north Wales requested one of its members to track it down on a visit to the United States. It was not a task that was quite so easy, America being a bit bigger than the good people of Corwen had imagined. The original is now held in Brown University in Providence, Rhode Island. Residents of Corwen – and those elsewhere – can find a more accessible facsimile in the National Library, Aberystwyth.

J

William Jernegan

Upon his death in 1836, his obituary described William Jernegan as 'the principal architect in the town and neighbourhood of Swansea'. He had a huge effect on the shape and character of the place in the early nineteenth century. Many of his designs have disappeared, though there are still fragments remaining that give a tantalising hint of what Swansea was and what it might have become until the copper intervened.

Sadly, what we know about Jernigan is very sketchy. He was born in 1749, perhaps in the Channel Islands, Norfolk, or possibly London. He may have come to Swansea as an assistant to the architect John Johnson, who in the mid-1770s designed two distinguished houses – Clasemont and the Gnoll in Neath. Jernegan is believed to have been left to supervise their construction then, after seeing opportunities in the town, decided to stay.

His fingerprints are all over the elegant buildings of his time, especially in the Burrows which became a particularly fashionable area. The buildings he designed included Burrows Chapel for Selina, Countess of Huntington, built in 1789 and Burrows Lodge, the home of George Grant Francis, both of which used to stand near where the museum is today. These, of course, have gone, but we can still see terraces he designed in Cambrian Place, Prospect Place and Adelaide Street.

He did some work on a series of country houses and villas on the Gower side of Swansea. He worked on the western part of Sketty Hall and also on Clyne Castle. He designed Sketty Park for Sir John Morris to replace his mansion at Clasemont and other prominent buildings such as Kilvrough Manor and Stouthall, the latter based on the design of nearby Penrice Castle. His reputation led to commissions from Cardiff and Milford Haven. He was involved in some building work at the county gaol in Cardiff. It was in a poor state of repair and the arches of the chapel had given way. In August 1815 he was exonerated of any responsibility for their collapse, since 'that part of the building was never under the superintendence of Mr Jernegan'. A building that has fared rather better is the museum in Milford Haven, one of the best surviving examples of his work. It was built in 1797 for the storage of whale oil awaiting transfer to London and has the kind of beautiful symmetry that calls for a camera.

In addition to working as an architect, newspaper advertisements suggest that he may have worked as a property agent or developer. In September 1804, when the Corporation offered 'leases for 99 Years, at a moderate rent to persons who may be inclined to build houses on the Burrows', there was an advertisement about property in Worcester Place. 'Four substantial modern well-built houses in perfect repair' were offered for sale and interested parties should contact Mr Jernegan who had 'plans of the houses and premises' and would give 'every information on the subject'. There was a similar advertisement in July 1809 about 'three commodious houses, fit for the residence of genteel families, being 2, 3 and 4 Bank Buildings, High Street'. Again you could apply to Mr Jernegan for further particulars.

As his career developed, he worked not only on domestic buildings but also on industrial projects. He drew up a design for 'A Copper Works on a Declivity' for the engineer Matthew Boulton, who owned the Rose Copper Works, though it is unclear if Jernegan's plan was ever used. In 1799, at the age of fifty, Jernegan proposed to Boulton's niece, Mary Mynd, who was considerably younger than him. Mary turned him down and he remained single for the rest of his life.

The Assembly Rooms may well remain as a fine legacy of his work, but their construction and financial arrangements were protracted and resulted in his bankruptcy in 1811. He did, however, recover and restore both his finances and his reputation. He died in 1836, aged eighty-six, at his home in Adelaide Place and was buried at St Mary's Church. You can find his flat gravestone on the northern side of the church, with the inscription just about legible.

However, an example of his work is that we can see whenever we choose is, of course, the Mumbles Lighthouse, which still lights up our lives and provides an iconic image of Swansea Bay at any time of the year. The Swansea Harbour Trustees had been given the power to provide a lighthouse on the Mumbles headland in the

William Jernegan's grave, St Mary's Church, Swansea.
(Author's collection)

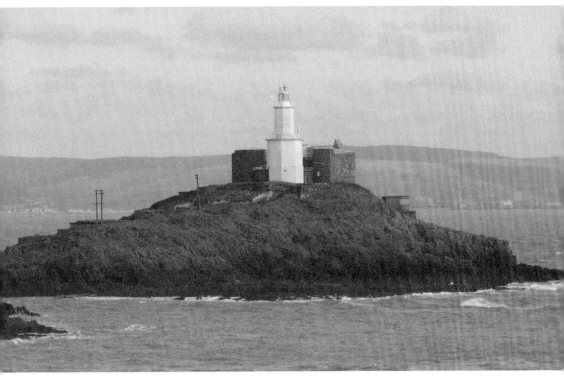

Mumbles Lighthouse. (Author's Collection)

Harbour Act of 1791. It was badly needed. The Cherrystone rocks and the Mixon shoals, approximately half a mile offshore, form two huge underwater obstructions which have sunk many ships, resulting in considerable loss of life over the centuries. Work began in July 1792, but in October the incomplete structure collapsed. So, in 1793, Jernegan took over the project, and under his supervision the lighthouse was finally completed and lit in 1794. It was constructed of stone and formed a tower with a smaller octagon on top of a larger one. The following year, a house was completed on the island 'for the person to live in who shall keep the lights'. In fact, the small island eventually housed a battery, or fort, to protect Swansea against a French invasion, a telegraph station and fourteen people, including the families of both the lighthouse keeper and assorted military personnel.

Initially, it displayed two open coal-fire lights, one above the other, to distinguish it from St Ann's Head Lighthouse, which had lights on separate towers, and Flatholm Lighthouse, with one light. However, the coal braziers were expensive and difficult to maintain, so in 1798 Jernegan, described as having 'a turn for mechanical inventions', converted the lighting to a cast-iron and glass lantern, which he designed and commissioned from the Neath Abbey Iron Foundry.

The lighthouse is something about which Swansea remains very proud. It was said, in 1892, that its guiding light 'rather seems to serve as an invitation to the haven of refuge than a warning to the mariner' – a fitting and positive way in which to remember William Jernegan.

The Kardomah

The Kardomah – Swansea's most significant and itinerant café. It has been fixed forever in the imagination as an aspirational hothouse of the mind for west-side posh boys with a yearning to be observers and commentators, far away from the grubby world of pollution and poverty. Their plans were made in the Kardomah.

The company that created the Kardomah brand began in Liverpool, in 1844, as the Vey Brothers tea dealers and grocers. The business was acquired by the newly created Liverpool China and India Tea Company in 1868 which distributed a range of brands, including Kardomah, a tea first served at the Liverpool colonial exhibition. However, the name only achieved significance in Swansea when the company gave it to a chain of heavily advertised coffee houses and opened a branch in the town: 'Kardomah Teas and Coffees may be tasted at the Kardomah Exhibition Cafe 232, High-street. Price 2*d* and 3*d* per cup, with biscuits.'

Kardomah became a place where people could meet and, perhaps, enjoy a more refined experience than in other parts of Swansea. It had a licence for playing music and provided a relaxing string quartet for exhausted shoppers. Kardomah promoted itself as a place of elegance and comfort. And promote itself it did. The newspapers at the end of the nineteenth century were full of brief advertisements, such as this one from the 1890s that they used quite a lot: 'Kardomah! Kardomah! Kardomah!' If nothing else, it has all the virtues of simplicity. In May 1895, the Kardomah provided coffee for a charity performance at the Theatre Royal, Temple Street, to raise money for improvements to the surgical department at Swansea Hospital. A few years later they had a stall at a fete in Brynmill Park, raising money for Swansea Lifeboat. Kardomah worked hard to stay in the public eye.

In 1897, they declared confidently that 'of all the Teas sold in this country, Kardomah will be found to be most refreshing, the most delicately flavoured, and the most wholesome. There is nothing harsh, insipid, or twangy about it'.

When the Congregational Chapel in Castle Street relocated to St Helen's Road in 1908, The Kardomah Café Co. bought the premises for a sum of £6,000 – 'the price which has been held out for by the chapel trustees. The company intend erecting an up-to-date and imposing looking structure'. *The Cambrian* said that the building was

Advertisment from 1908. (By kind permission of SWW Media)

'among the most striking in the town – snow-white from roof to basement'. Among those who had been married there were Dylan Thomas's parents in 1903.

Despite such splendours, these were tricky times for a Kardomah manager. In January 1915, Mr Pickard had to calm his waitresses, who went on strike when he was out at lunch, and then, in May 1919, he was sued by Mrs Colebrook of Walter Road. She alleged her handbag had been stolen through an open window facing the back lane. She had left it on the window ledge while taking tea with her sister-in-law. When she complained to the manager of its loss, he told her she should look after her bag. 'I really can't do anything for you,' he said, and you can see his point – particularly since the two ladies couldn't agree whether it was the bottom or the top of the window that was open. If it had been the top window then it would have required a thief with extremely long arms. The case was dismissed.

The café achieved its greatest fame when it became the meeting place for a group of friends, the Kardomah Gang, who came to represent Swansea's artistic aspirations. It was a warm and cheap place to sit and talk and was, more importantly, close to the offices of the *South Wales Evening Post*, where the young Dylan Thomas and Charles Fisher found work after leaving school. The gang, some of whom had been in school together, gathered around Thomas and Fisher during the 1930s.

Charles Fisher was a journalist, traveller and poet who worked for British Intelligence in France during the Second World War and later moved to Canada.

The poet Vernon Watkins was often there – Dylan Thomas's closest friend and the only person from whom he would take advice about his work. The composer Daniel Jones was a member of the group, and it is a remarkable coincidence that both he and Vernon Watkins did their military service during the war at the Bletchley Park Code and Cypher School, where they tried to penetrate the enemy's secret messages. They were both cryptographers, with Jones specialising as a decoder of Russian, Romanian and Japanese texts.

Other members of the Kardomah Gang included the Welsh artists Alfred Janes and Mervyn Levy – you can see a portrait of the latter, painted by the former in 1935, in Swansea's Glynn Vivian Art Gallery. Janes produced paintings of most of the members, including significant portraits of Thomas, Watkins and Jones. Levy became an important art critic and teacher.

This was certainly a golden generation, and it is the reason why the Kardomah has such a significant reputation in Swansea's intellectual history. Fisher was the last surviving member of the Kardomah Gang. He died in Bangkok, in 2006, when he was ninety-one, but the legendary status of the gang was by then well established.

Of course, Castle Street and the Kardomah were destroyed in the Blitz of 1941. In his 1947 radio broadcast, *Return Journey*, Thomas described it as 'razed to the snow' and that destruction represented something else for all those who had once gathered there – the destruction of an important part of their past. They could never go back.

The Kardomah Café reopened in the 1950s in a new location in Portland Street, and remains popular for its qualities as a café and for the authentic '50s decor. The Swansea-born screenwriter Russell T. Davies used it as a location for a scene in an episode of *Doctor Who* called 'The End of Time'. A fitting title, perhaps. It is the only surviving operational branch of a national chain, but it is so much a part of Swansea's A–Z that, perhaps, the Kardomah will indeed last a great deal longer.

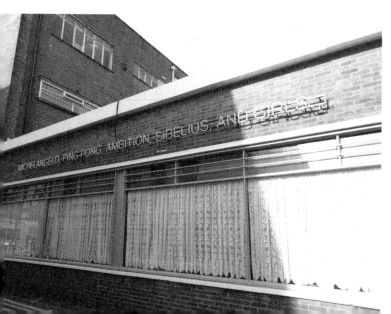

The Kardomah on Portland Street remembers the Golden Age. (Author's collection)

L

RMS *Lusitania*

I found a quotation in an old newspaper that claimed, 'Swansea men are sure to be in any event that causes a universal or general attention.' It does seem to contain a grain of truth. Swansea was represented when the *Titanic* went down, among both passengers and crew. It was there when the World Trade Centre went down in clouds of dust in New York in 2001. And it was there too, perhaps even more importantly, when the RMS *Lusitania* went down off the coast of Ireland. If anyone should ever tell you that Swansea is merely a backwater, then remind them that it played an essential part in America's entry into the First World War, thus changing world history forever.

The RMS *Lusitania* was for a while the largest passenger ship in the world, noted for its speed and luxurious fittings. Her maiden voyage was in 1907, when one of the officers was Aaron Dann from Swansea.

There were secrets about the RMS *Lusitania*. The British Admiralty had covertly subsidised her construction, so when the ship left New York for Liverpool in May 1915, the ship was carrying hidden munitions. The Germans knew about it and placed an advertisement in the American press warning passengers of the dangers of travelling in a ship that they now regarded as a legitimate target.

On 7 May 1915, as the ship neared the coast of Ireland, it was hit by a torpedo fired by a German submarine. A second explosion then ripped the liner apart when the hidden cargo was ignited. The ship sank within eighteen minutes and 1,119 people of the original 1,924 perished. Significantly, 114 of the dead were Americans and this event – 'The *Lusitania* Murders' – began to turn public opinion in the United States in favour of their country entering into the war and the key figure in this was seven-year-old Helen Smith, who was born in Swansea in October 1908.

Her parents, Alfred and Elizabeth, moved to the United States in 1909, initially living in New York and later near Pittsburgh, where Alfred worked as an electrician. They were joined by Alfred's sister Cecelia and her husband, Hubert Owens, and sons, Ronald and Reginald.

However, the Smith family decided to return to Wales. Elizabeth could not settle in America, while Alfred wanted to make a contribution to the war effort. Cecelia and her boys went along to visit their grandparents. They deliberately chose to sail on the

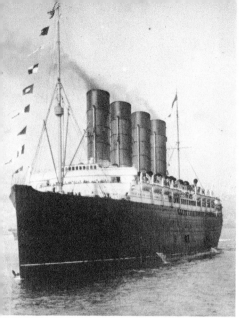

The RMS *Lusitania* leaves New York. (By kind permission of the American Library of Congress)

RMS *Lusitania* because Aaron Dann had once arranged a tour of the ship for Alfred's father, Captain Smith of Bryn Road, a well-known Swansea seaman.

Helen was playing on deck when the torpedo struck at 2.10 p.m. The ship immediately began to list to starboard. Desperately searching for her parents, Helen ran along the deck and straight into Canadian journalist Ernest Cowper. He gathered her up and unsuccessfully looked for her parents. At the same time, Cecilia saw Alfred and Elizabeth searching frantically for Helen with her baby brother Hubert in their arms. Alfred persuaded his sister to dive into the water and swim away from the ship. When she looked back, she watched the liner slide beneath the surface with the Smith family at the rail. Cecelia was pulled into a lifeboat, but like Alfred and Elizabeth, her sons were lost. Their bodies were never identified.

Cowper and Helen climbed into lifeboat thirteen, were rescued and taken to Queenstown in Ireland where they met Cecelia, still searching for her two boys. Helen was quite untroubled, convinced that her parents would turn up very soon.

Helen's story grabbed the attention of the world's media and her photograph in the arms of Cowper flashed around the world. This innocent Swansea-born girl became a powerful propaganda tool, a symbol of German barbarism and a focus for international outrage. As the *Flintshire Observer* so eloquently put it, 'The ruthless sinking of the *Lusitania* by a German submarine marks the climax of a series of ferocious atrocities unequalled in the darkest annals of barbarism.' The wife of the ship's captain offered a reward to the captain of 'any British craft who proves that they have sunk German submarines. The *Lusitania* must be avenged'. It was an issue that endured. It was reported in July 1918 that 'Lusitania!' was the 'stirring battle cry of American soldiers' as they advanced into battle.

Helen's uncles went to Ireland to collect her and the *Cambrian Daily Leader* reporter was touched when Helen and Cecelia arrived at Victoria Station in Swansea in

THE LUSITANIA HORROR.

All the Worst Fears Realised.

OVER A THOUSAND INNOCENTS MURDERED.

Blackest Crime in History.

220 AMERICAN CITIZENS PERISH.

ADMIRALTY MESSAGE STATES OUT OF 1,978 SOULS ON BOARD THE LUSITANIA 705 SURVIVORS HAVE BEEN LANDED ON THE IRISH COAST, TOGETHER WITH 45 BODIES.

Although the Germans had repeatedly threatened to sink the Lusitania, and specifically warned the passengers at New York on the last voyage of the intention to torpedo her on that particular trip, the news published in the "Daily Post" on Friday evening that the liner had actually fulfilled their threat, and thus flouted the entire civilised world, was received with keen indignation, coupled with expressed determination that we prosecute the war to a successful issue, and exact full and complete punishment for these barbarities. The first news of the sinking of the liner off Kinsale, in the South of Ireland, reached Swansea shortly after 3 o'clock, but it was not made known officially until shortly before 8 p.m.

There were a number of passengers with Swansea and West Wales connections on board, and the "Daily Post" doorway was thronged until a late hour by people anxious to hear the latest.

An extraordinary feature of the disaster was the scarcity of definite information up to early on Saturday morning as to the fate of all the passengers, but no details filtered through later the appalling nature of the crime became gradually known.

By kind permission of SWW Media.

one of those little scenes that are too deep for words, that make anyone within several yards feel an intruder ... Mrs. Owens was almost in a state of collapse, and indeed upon her arrival at Manselton, the doctor who visited her gave peremptory commands that she was to be seen by no one until she had recovered from her state of distraction.

Survival had made Helen famous. She received many letters, including one from Queen Mary. Cowper wanted to adopt her, as did many others, including an American millionaire and a French heiress, but she was brought up in Swansea by her mother's family. Initially, she was a small American girl with short hair in a foreign land who spoke only English, while her grandmother spoke only Welsh. It didn't matter. She was soon absorbed into a large and supportive family in Manselton, which already contained twelve children. Helen became a mascot for the Manselton Girl Guides and sang a solo at the Manselton Congregational Church at a service for the dedication of their colours. As a result she became, according to the newspapers anyway, much in demand as a local concert artiste.

She remained in touch with Ernest Cowper, who had saved her life. He wrote to her frequently and sent her presents at Easter and Christmas but, thankfully perhaps, Helen's celebrity status in Swansea soon faded. She worked in a shoe shop and married John Thomas in 1931. Together, they had two children, including a daughter named Elizabeth after the mother she lost. Helen died in Swansea in 1993. When interviewed on her mother's death, Elizabeth said, 'She rarely talked about the disaster and I know she hated the notoriety it gave her as a child. She retained a morbid fear of water and rarely travelled outside Wales. But she lived a full life until she was 84.' Helen Smith was the last survivor of the RMS *Lusitania*.

Mr. Ernest Cowper, the Canadian journalist who was on board, and little Helen Smythe, whom he saved. Mr. Cowper is one of the few people who saw the submarine. [Photopress.

By kind permission of SWW Media.

Death of liner survivor aged 84

A SWANSEA WOMAN who survived the sinking of the liner Lusitania in the first world war, has died aged 84.

Helen Thomas (nee Smith) was aboard the Cunard ship when it was torpedoed by a German submarine in 1915. She was then aged just six.

Her parents, her brother and two cousins were among almost 2,000 people who perished at sea.

Mrs Thomas was saved by an American journalist who made sure she got safely on to a boat. An aunt also survived.

The family was returning to Britain after in the United States for several years when tragedy struck.

The sinking of the Lusitania, which also claimed American lives, brought the US into the war.

Mrs Thomas, who was brought up by her grandparents in Manselton, went to Glanmor Girls School and became an active member of St Michael's Church.

She died at the Fairleigh House nursing home in Sketty Lane on Maundy Thursday.

Her husband Jack, a buyer for city wholesalers J T Morgan and Co, died in 1956.

Their daughter Elizabeth Joseph lives in Pennard and son John Thomas in Shrewsbury.

Mrs Joseph said: "My mother was born in Swansea but the family emigrated when she was about six months old. They didn't really settle in America and decided to return to Wales."

By Gary Spinks

Mr Thomas added: "When the ship was torpedoed my mother was playing and was among children who were put into the lifeboats first.

"Even though she was only young at the time she could still remember later many things about the sinking.

"She was one of the longest living survivors from the tragedy."

Helen Smith with her parents at the age of six.

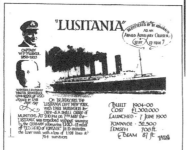

A postcard souvenir of the sinking of the Lusitania.

By kind permission of SWW Media.

Ll

Llys Newydd

Llys Newydd lies alongside the River Tawe in Llansamlet opposite Morriston, and it is a place with a neglected history. The name means the New Court, or Hall of Justice. It is said that it once belonged to the princes of Dynevor and was the legal centre and court for the eastern part of Carmarthenshire. The nineteenth-century Llansamlet historian Edward Hughes said,

> A place bearing the name of Cwmdial (the Vale of Revenge or Punishment) is supposed to be the spot where executions, following condemnation at the court, were carried out. There was a farm with this name on Tydraw Road in Bonymaen. A house called (and still called) Llety'r Angau (the House of Death) appears also to have been used as a place of punishment connected with the same court.

In 1873, the Morriston historian, Phillip Morgan, commented that this building was still standing: 'There are portions of huge iron hinges now projecting out of the wall, on which, undoubtedly, a massive door opened and closed on this cell or prison.'

There was a time when Llys Newydd was described as 'one of the most fertile spots in Glamorganshire – a paradise surrounded by cultivated hills.' Its orchards were 'remarkable for the abundance and deliciousness of their fruits, being highly productive of pears, apples, and grapes, and the wines made here were of the choicest

Author's collection.

quality'. They were able, it seems, to harvest their corn in August, earlier than anyone else, so that it was ready for sale on 12 September at Neath Fair.

Everything changed in 1730 when copper and lead works were established in the neighbourhood.

In February 1778, *Hansard*, the journal of the House of Commons, reported the approval given to the building of a bridge, along with 'proper avenues or roads to and from it', across the Tawe to facilitate trade. Existing communication was by ferry, 'which at all times is attended with delay, difficulty and danger'. The bridge between Llys Newydd Marsh and the opposite bank was to the north of Morris' Weir. We know it as the Wychtree Bridge, and it was a huge boost to industrialisation.

Mr Murray's announcement in *The Cambrian* in October 1822 illustrates this perfectly. He offers parts of Llys Newydd Farm for rent on a sixty-year lease; his advertisement is targeted quite specifically: 'To the Copper Companies.' Productive farming land was poisoned and the sulphurous gas from copper production was the price that had to be paid for employment.

Inevitably, Llys Newydd was 'one of the first spots which felt the withering effect of the smoke'. Land continued to be held for some time by tenant farmers, 'who one after the other strove to cultivate it for a living; but the odds were too heavy on the side of copper and lead'. The factory owners tried to dissipate the smoke by building high chimney stacks but this didn't make it disappear, it merely spread the smoke over a wider area.

In 1832, eleven farmers from Llansamlet took out an indictment for public nuisance against the Vivian Copper Works. The subsequent Copper Trial of spring 1833 was a remarkable moment in industrial and environmental history. It set town against country, farmers against industrialists, rich against poor, English against Welsh.

Of course, they failed; the farmers were fighting the industrial might of the establishment. The Vivians employed the former attorney-general Sir James Scarlett to defend them. The farmers employed John Evans, a solicitor from Merthyr. In terms of professional experience, it was a completely uneven contest. As Evans himself pointed out, the representative of the farmers, Thomas David, is 'a person in a humble situation

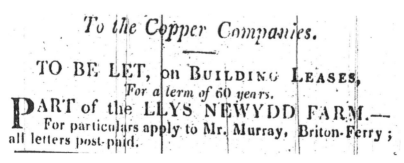

By kind permission of SWW Media.

of life, and lives in the parish of Llansamlet. The defendants are persons of great opulence and by their wealth were enabled to get the assistance of the great Leader of the English Bar'. And that great leader went to work on Thomas David.

Scarlett said a guilty verdict would bring economic ruin to Swansea. He dismissed suggestions that crops had failed and that animals had died; they were merely the consequence of bad management, since 'Welsh farming methods were backward.' Copper smoke? What was the problem? It was 'a shield against cholera' and other diseases. Children in the copper districts were 'renowned for their cheerful dispositions and healthful and florid countenances'. The jury, so convinced by his presentation, tried to deliver their verdict before the judge had finished his summing up. He made them wait, and then they pronounced a verdict of not guilty.

There was 'an unusual degree of interest' in the case 'from its vast importance to the welfare of the Town and Trade of Swansea, as well as to the Copper Manufacture of the British Empire at large', and its defeat was greeted with great acclaim and relief. The needs of the whole community were more important than the distress of the farmers.

However, John Evans had clearly outlined the effects of copper smoke and whatever anyone else thought, they were inescapable. He told the jury, 'Here is a pestilential work in the neighbourhood of Swansea, spreading poverty around, and the only remedy is to look for redress at your hands.' The details he gives are shocking. When the cows became so ill that they could not stand, grass was cut, and placed by their sides:

All the cattle, who eat the grass on which this sulphurous acid falls, immediately begin to suffer in their gums and teeth, and even their bones are affected, their glands swell, become feeble, and they fall to the ground and die ... corn is blighted in these farms when it blossoms, and never comes better, it never fills afterwards ... the crops of corn were worth nothing.

The last of the farmers who lived in Llys Newydd was Isaac y Cybydd (Isaac the Miser) and, after his death, his house was believed to be haunted: 'This caused it to be unoccupied for some time. Afterwards it was used as dwelling-houses for working people, and then it passed away entirely, its site being now taken up by the steel works.'

There was an advertisement in November 1873, which I find provides all the evidence that you might ever need about how the Lower Swansea Valley changed: 'For Sale by Public Auction. LLANSAMLET ARSENIC WORKS, situate on the Llys Newydd Marsh, in the parish of Llansamlet.' Llys Newydd. Poisoned for the People.

The Women of Mumbles Head

The Cambrian newspaper said, 'Living memory holds nothing to compare with it and local history offers no parallel.' It was a terrible day: a south-westerly gale on 27 January 1883 caused the deaths of over fifty people, including four of the Mumbles lifeboat crew.

The storm broke at around 5.00 a.m. and within thirty minutes the *Agnes Jack*, sailing from Sardinia to Llanelli, was in serious difficulties at Port Eynon. The crew were seen clinging desperately to the rigging, but the ship was swamped and eighteen men were lost.

The French schooner *Surprise* sank at Overton: 'The only living thing that came ashore was a black dog and the poor animal, which was wholly unhurt, was kindly treated by the Overton people.' Bodies were washed ashore for a number of days.

In the evening, the Porthcawl lifeboat telegraphed Mumbles for assistance in rescuing the crew of the *James Grey* from Whitby. It sank on Tusker Rock with the loss of all twenty-five members of the crew – they could not understand why the Mumbles lifeboat hadn't turned up. It was quite simple. It had sunk.

You see, things had not gone well at Mumbles either: 'In Oystermouth the state of things was piteous in the extreme.' The German ship *Prinz Adalbert*, sailing from

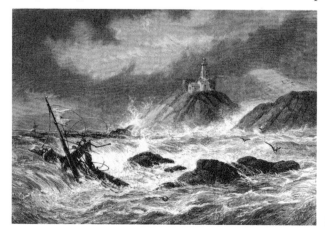

By kind permission of the British Library.

France to Swansea with over 900 tons of pitwood, had been in considerable distress during the morning. The Swansea tug *Flying Scud* was attempting to tow it to safety, but the towrope snapped and *Prinz Adalbert* drifted into the rocks at Mumbles Head. The lifeboat *Wolverhampton* was launched and, despite the heavy seas, a line was fixed between the two vessels. Two members of the *Prinz Adalbert's* crew were safely transferred, but when the third man was in transit, the lifeboat's anchor cable snapped. *Wolverhampton* was overturned and the men thrown into the water. The lifeboat righted itself and men scrambled back aboard, but it was hit by another wave and capsized.

The crew were dashed against the unforgiving rocks. Four of them died and others were badly injured. Of the survivors, two were rescued by Jessie Ace and her sister Margaret Wright, daughters of the lighthouse keeper. They waded into the surf up to their armpits and, with the help of Gunner Hutchings from the lighthouse fort, rescued John Thomas and William Rosser, using shawls as lifelines to pull them in. The coxswain, Jenkin Jenkins, was found badly injured after having washed up in Bob's Cave on Mumbles Head. He lost two sons, John and William, and his son-in-law, when the lifeboat capsized.

Ironically, the crew who stayed on board the *Prinz Adalbert* were perfectly safe. When the tide receded, they simply walked ashore unharmed. The ship broke up on the rocks the following day: 'Her timbers and cargo were strewn all round the Bay and the Coast.' Six men were prosecuted for unlawful possession of wreckage as people began to collect it.

In March, Jenkin Jenkins received a silver medal from the RNLI and £50, while Gunner Hutchings was given a framed engraving of thanks, £2 and a telescope. The Mayor of Swansea, who made the presentation, dismissed suggestions that the Gunners stationed in the Mumbles Battery had done very little. He said that it was Hutchings who threw out a rope to the two men and pulled them in. But in protecting his reputation, he dismissed the part played by the two women: 'Mrs. Wright and her sister rendered all the tender assistance that could be expected of brave women in such an emergency.' At least the Empress of Germany recognised their role when she sent the Ace sisters the thanks of the country and two silver brooches 'consisting of a splendid carbuncle of oblong shape, set in a solid gold oval, with the German Imperial crown atop, surmounted by a miniature cross, the whole being relieved by seventeen small brilliants, which added much to the beauty of the effect'.

However, the Ace sisters seized the popular imagination. Their photographs were sold by Mr Chapman, Swansea's photographer, who sent copies to Queen Victoria. *Punch* magazine said Jessie was 'clearly not only an Ace but a very Ace of Trumps'. Their reputation was assured by a poem written by Clement William Scott (1841–1904), the drama critic of the *Daily Telegraph*. 'The Women of Mumbles Head' has rhythm and momentum and, more than anything else, imprinted the two women in the popular imagination. It was published in *Theatre Magazine* in March 1883, although it had been performed at the end of February at the New Theatre in Swansea, to raise money for the Disaster Fund, when it was 'recited with excellent elocutionary and characteristic effect' by Sallie Booth. For at least the next thirty years, the poem was a staple of the

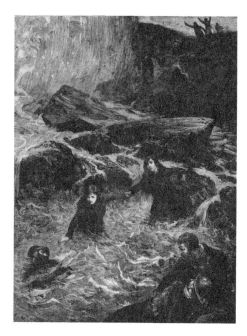

Author's collection.

music hall repertoire across the country. It featured in entertainments welcoming troops home at the end of the First World War. It was an enduring celebration of heroism, and Jessie and Margaret were rewarded with the kind of immortality only literature can give you:

> 'Come back', said the three strong soldiers, who still stood faint and pale,
> 'You will drown if you face the breakers, you will fall if you brave the gale'.
> 'Come back?' said the girls. 'We will not, go tell it to all the town,
> 'We'll lose our lives, God willing, before that man shall drown.'

There was a lot of poetry about. Charles Bevan, the secretary of the lifeboat station in Port Eynon, wrote about the loss of the *Agnes Jack* and his poem was performed every year on the anniversary of the disaster:

> And in the rigging human forms
> Were clinging for their lives,
> We gazed with pity on them there,
> For help we heard their cries.

No, we should never dismiss the power of Clement Scott's 'Women of Mumbles Head'.

When Jenkin Jenkins died in April 1893, *The Cambrian* reported his memories of the disaster. He remembered abusing soldiers on the rocks: 'You scoundrels, save the men, for shame! Don't let the men drown before your eyes.' He remembered his

dead son, John, floating past him. But he was adamant about the part played by the 'Women of Mumbles Head':

> They tied two shawls together, and both of them threw them into the water. They almost went out of their depth to save these men, and were both in the water up to their armpits. The soldiers did throw something into the water resembling a clothes line, but they did not go near enough to throw it to reach them.

Against the wall of All Saints Church, you can find the gravestone of his son William, who was thirty-five when he died. He is remembered, along with his three-month-old son who died four years earlier, almost to the day. The gravestone that once remembered John, who floated past his father dead in the water at Mumbles, and his three children, was wantonly smashed in 1983.

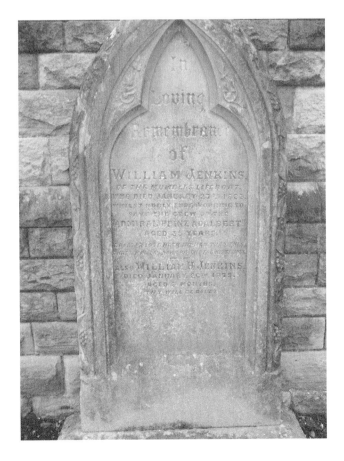

All Saints Church, Mumbles.
(Author's collection)

Richard 'Beau' Nash

It seems an odd way to live your life, as a celebrity party organiser and arbiter of fashion. But this is what Richard 'Beau' Nash did. He became famous for not doing very much at all. Clearly a man ahead of his time.

He was, in his own words, 'born in an obscure village and from mean ancestors' in October 1674. Well, that's Swansea for you. After school in Carmarthen, his father sent him to Jesus College, Oxford, but he was not a success. Nash was asked to leave when he was seventeen after committing the terrible crime, for a student, of proposing marriage to a local woman. In a brief biography in 1899, *The Cambrian* newspaper commented that 'it was probably the last offer of marriage he ever made, his later love affairs being far more disreputable.'

His father next bought him a commission in the army, where he gained a reputation for an exquisite taste in dress and a complete disregard of military obligations. Next he tried the law. He became a member of the Inns of Court, though again he showed minimal commitment. No one was sure where his money came from – some believed that he was a highway man on Hounslow Heath – but his primary occupation was as a gambler, and not always a successful one. It is said that he once had to beg at the door of York Cathedral wrapped only in a blanket. On another occasion, desperate to win a bet, he rode naked through a village on the back of a cow. You can take the boy out of Swansea, but...

Things changed when he was asked to manage a banquet held on the accession of William III, and suddenly he found his vocation as a master of ceremonies.

In some unexplained way this took him to Bath, where he developed a relationship with the city that lasted over sixty years and brought him lasting fame. He began as the assistant to the Master of Ceremonies, Captain Webster, who arranged and managed Bath's social life – balls, dances and social gatherings. When Webster was killed in a duel following an argument about a card game, Nash became his natural successor and soon the uncrowned king of Bath. By 1716, he had been granted the honorary freedom of the city by its grateful elders.

After all, when he arrived in Bath, it was a small spa resort catering for the sick and the worried well. When he died in 1761, it was the most important place in

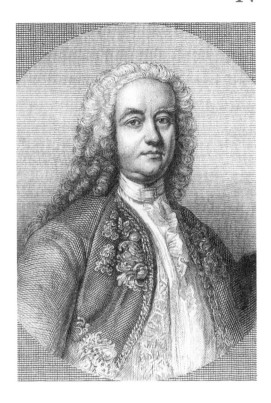

Richard 'Beau' Nash. (Author's collection)

eighteenth-century Britain. His successful formula was very simple. He found visitors something to occupy their time – gambling. He also established a band in the Pump-room, which brought the healthy as well as the sick to the springs and gave Bath a reputation for entertainment to rival the one it once had for its reviving waters. He employed local builder, Thomas Harrison, to build the Bath Assembly House which became the central venue for dancing and gambling.

His was an unofficial role, but extremely influential. Nash would assess new arrivals for their suitability, arrange marriages, introduce dancing partners and, most importantly, regulate gambling – the shadowy world that supplied his income. He effectively determined what people wore and how they behaved. For example, concerned by Webster's death, he banned the carrying of swords to reduce the risk of violent disputes. When the Duchess of Queensberry appeared in the ballroom in a white apron, Nash ripped it off and told her it was only suitable for a servant. He preferred shoes, so when a man appeared wearing boots, Nash would shout loudly, 'Sir, I think you have forgotten your horse.' Shoes were suddenly all the rage.

Nash was described as 'coarse and ungainly in person', but he always dressed flamboyantly in a white hat and 'with gold lace enough for an emperor'. Mercifully, he never lost the capacity to laugh at himself. Few people knew that his origins were comparatively humble and that his father was a partner in a glass business at Swansea. When it was revealed, he said 'I seldom mention my father in company,

yet I do not have any reason to be ashamed of him because he has some reason to be ashamed of me.'

Inevitably, things changed. In the 1740s, Parliament reduced the number of permitted games involving cards and dice, which effectively sabotaged his income and he slipped into poverty, stranded in the past by a world that had moved on. He was eighty-seven when he died, in April 1761. As *The Cambrian* said, he 'became disliked and despised where he had once ruled supreme', telling stories of his triumphs to anyone who would listen, dressed in yesterday's clothes. He was 'honoured with a showy funeral, worthy his days of glory'. Then he was buried in a pauper's grave.

There are memorials to Beau Nash in Bath, of course. In Swansea, the house where he was born in Goat Street once displayed a memorial plaque. Sadly, both plaque and Street were destroyed in the Blitz in 1941. The building that stands on the site, once Sidney Heath's Store, is Beau Nash House.

I have one final story about Nash. It is said that when he died, his impoverished mistress Juliana Popjoy, also known as Lady Betty Besom, was so distraught that she resolved 'never more to lie in a bed' and spent the next thirty years living in a hollow tree near Warminster until her death in 1777. It is a detail that I would very much like to be true, though I imagine it is a legend. But it seems appropriate that the story of such a dedicated creator of fashion should reach its conclusion inside the emptiness of a hollow tree.

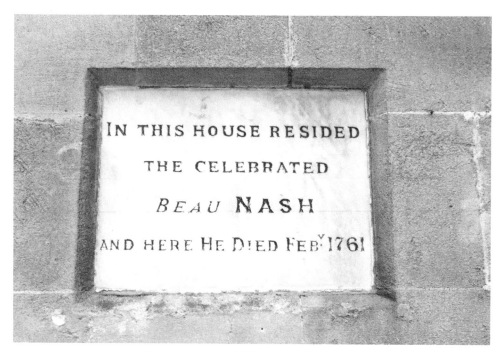

Remembered in Bath. Photograph by Rebecca O'Brien. (By kind permission)

O

The Orange Peel Nuisance

Earlier, we saw how Swansea residents have always been keen to bang off letters to the press when agitated, and for over seventy years they submitted angry letters about orange peel. At the merest whiff of one of Valencia's finest, they would rush to condemn the Orange Peel Nuisance.

At the start of the nineteenth century, orange peel wasn't much more than a handy missile with which you could express your opinions at the theatre. Enthusiastic audience participation of this kind would sometimes leave the Drury Lane Theatre in London looking like an explosion on a fruit stall. It was much more of a problem when it was dropped on the street.

In July 1839, 'An Old Inhabitant' dashed off a letter lamenting the state of Swansea and reflecting on the disturbing increase in fruit-based litter since the appointment of policemen, who seemed to do nothing about it. There was, he said, great danger in 'stepping upon some of the numerous pieces of orange peel with which our foot-paths are constantly strewed'.

In October 1845, a correspondent called 'Humanity' had an unfortunate encounter in the street: 'The writer fell down, and it is a mercy his arm or leg, or both, were

Prompt action by local author prevents unpleasant incident on Green Dragon Lane. (Author's collection)

not broken.' He ended his letter in anticipation of a better future: 'My motive in thus troubling you with this is the hope that those who practice such bad habits may learn to do so no more.' A vain hope, for later years offered little improvement.

In April 1876, Mr Jenkins, landlord of the Music Hall Hotel, died of injuries received following a fall on a piece of orange peel on Oxford Street:

> He received so severe injuries in the head, and was taken home, and after lingering two or three days expired on Monday. We hope his sad case will prove a caution in the future, and pedestrians will do well to kick into the gutter all peel thrown upon the pavement by incautious persons.

It did not get any better. R. Sutherland wrote to the newspaper offering a 'timely warning to all who indulge in so careless a habit as throwing orange peelings on footpaths'. He saw a man in Oxford Street 'measuring the hard pavement with the length of his body'. Something should be done. There should be fines at the very least. An editorial supported the idea: 'Let every good citizen see to it that the pavements are kept free from treacherous peel.' Sadly, they were not, and incautious residents continued to find their arms in slings. In January 1882, *The Cambrian* felt it appropriate to reprint a piece from *The Lancet*:

> The police authorities have issued a circular warning the public against the practice of dropping pieces of this slippery rind on the foot-paths. Why do they not go a step further and instruct constables to take the trouble to kick those droppings off the pavements? The men have little to occupy their minds, and look very miserable on their rounds.

A policeman's lot has never been a happy one.

Some struggled to take the carnage seriously. *The Cambrian* had a regular 'humorous' column called 'Varieties', where in 1883 it announced, 'It's about an even thing between man and the orange peel. Sometimes the man throws the orange peel into the gutter, and sometimes the orange peel throws the man into the gutter.' Later in the year, readers were told, 'Orange peel is said to make excellent slippers,' which naturally had readers rolling in the aisles. Or, indeed, the gutter.

Of course, traditional orange-themed pastimes hadn't completely disappeared. In 1893 it was observed that during public performances at the Albert Hall, the audience 'needed more amusement, or, at any rate, more mischievous amusement, than is sometimes provided for them on the stage'. When things were slow the audience would throw orange peel into the organ pipes, 'to the detriment of the musical performances of that instrument, and of the luckless professors who attempt to play it under those disabilities'. There are times, even in the theatre, when you have to make your own entertainment it seems.

The problem continued into the twentieth century. In 1904, Thomas Thomas from Hafod broke his leg in a peel-related incident. In 1905, Mrs Rees from Manselton slipped and fell, cutting her lip. In 1908, a visitor from Mountain Ash fell and grazed his knee. Less fortunate was Edward Williams of Graig Terrace, who was admitted to Swansea Hospital in March 1905, suffering from serious injuries to the head, 'received in a fall, four days previously'. He died, having 'accidentally slipped on a piece of orange peel'.

But for me, the climax of these stories had happened in April 1904: 'Three weeks ago the papers reported the fact that a man fell from a stack 40 feet and received no injury. He had got up and was walking away as though nothing had happened, when he trod on a piece of orange peel, fell on his head, and was killed instantly.' This is all there is – no name, no details. But why spoil a good story with facts?

By 1907 the provision of 'wire receptacles, suspended in various parts of Swansea for the depositing therein of sundries, and especially orange peel and the like,' was not an unqualified success: 'if the fragments of peel hourly to be seen thrown on the town's pavements are a criterion'.

But even the world of fruit waste has to move on. The end of the 'Orange Peel Nuisance' was in retrospect quite predictable. It was superseded by the 'Banana Peel Peril'.

SS *Polaria*

It was July 1882 when the SS *Polaria* docked in Swansea. It had been launched on the Tyne by Mitchell & Co. in February that year for Carr Line of Hamburg. It had been specifically designed for the emigrant service operating between Hamburg and New York and could accommodate over 1,000 passengers. Carr Line had been contracted to carry 18,000 people during 1882 and the SS *Polaria* was a part of the huge fleet that was populating America. Crossings normally took between seventeen and nineteen days. This was its second trip.

The SS *Polaria* was docked in Swansea for three days in order to pick up a cargo of coal and tinplate, and during this time it became 'the object of the highest interest on the part of the local community'. It was a remarkable window into another world.

There were 731 passengers on board and suddenly a lot of them were out on the streets early on Monday morning, no doubt very grateful to feel the solid ground beneath them for a while. Few of them would have ever travelled this far before, and

THE "POLARIA" GERMAN EMIGRANT SHIP AT SWANSEA.

Swansea people have this week been brought face to face with the stern facts of emigration in an hitherto un-wonted fashion, by the visit to our port of the fine steamer "Polaria," on her voyage from Hamburg to New York. The attention of the townsfolk was especially awakened to this interesting fact by the crowds of foreign people who promenaded the streets early on Monday morning. From the appearance and language of those who first came ashore, it was thought that the whole of the emigrants were distressed Jews, from the troubled dominions of the Czar of Russia, and the Emperor of Germany, but a further acquaintance revealed the fact that the majority of them were Germans, from various

The Cambrian. 7 July 1882. (By kind permission of SWW Media)

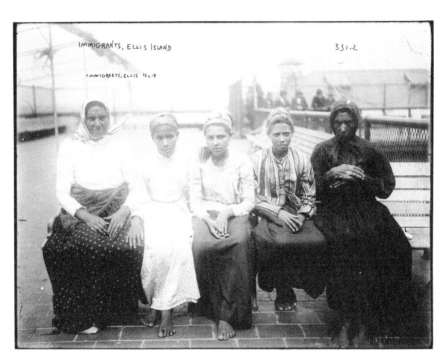

Searching for a new life. (By kind permission of the American Library of Congress)

they still had to face the Atlantic. Swansea has always been a busy port; sailors from all over the world knew its streets. The town had always done its best to accommodate them – and to take their money – though they were always regarded with suspicion and as a potential source of disorder. It was certainly unusual to see foreigners in such large numbers as this, and it became a big news story.

The Cambrian reported that the majority of the passengers were Germans 'from various areas of the newly constituted but not as yet well consolidated German Empire'. While the cargo was being loaded, they became a local curiosity. They were 'stared at and joked about by the small-minded and the thoughtless idlers'. Soon the locals gathered at the docks for a closer look and many were taken on a tour of the ship. It is described as a small town, 'with a most diverse population'. There were nearly 200 Russian and Polish Jews from the 'troubled dominions of the Czar', where they had been 'cruelly treated'. They are of a 'very degraded standard' and dressed in rags. Their 'faces and hands would be all the more seemly for a freer use of the soap and water which are so liberally supplied on board ship'. Their fares were paid by international relief committees, and they do seem to have been in particularly difficult circumstances.

The newspaper maintains a superior tone throughout, with a patronising mix of sympathy and outrageous prejudice: 'The odours that ascend from their quarters are not of the sweetest kind.' The reporter suggests that the Jewish emigrants may not be as poor as they look; he writes about 'the Semitic type in their physiognomy' and

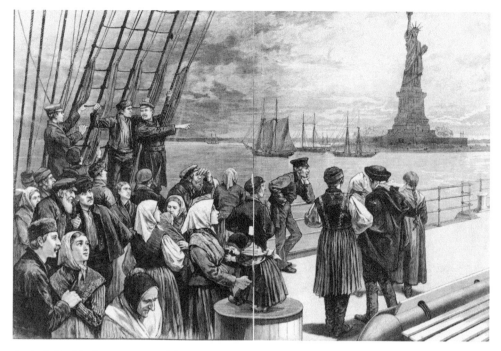

Arrival. (By kind permission of the American Library of Congress)

their 'peculiar genius' for 'petty bargaining' and 'money changing'. He considers the diaspora and remarks that 'the fabled time for the restoration of the Jews in Palestine is evidently not yet fully come'. He observes that the 'sacred land is wonderfully productive' and could once again yield 'splendid harvests of cereals, olives and grapes'. But there appears to be no appetite for the creation of a homeland 'in spite of the cries of the devout in the place of wailing in Jerusalem'. The 'wide wild West' appears more attractive: 'So let them go, and may the blessing of their Jehovah rest upon them! May they be a blessing to themselves.' However, he goes on to add that they will 'entail no curse upon the peoples among whom they may settle'.

The reporter is more comfortable with German passengers, who are 'respectable working class, clean in habits'. They paid around £5 for their passage, though 140 of them had tickets prepaid by family and friends who had already made the journey. There were new passengers as well, for two children were born: one off Mumbles Head and the second while the ship was in dock. They were both boys, and while they may have taken their nationality from the boat on which they were born, he was relieved that it was hardly likely that 'these youngsters will ever be drafted into the German armies'.

While the Germans are obviously a militaristic nation, the Welsh are forever moved by compassion. One of the visitors to the ship was a 'thorough Welsh woman in Welsh flannel bed gown attire'. She saw weakness and exhaustion in one of the new mothers: 'Though she could not convey her meaning in words, she did so in looks. The mothers

understood each other and the warm-hearted Welsh woman took up the little one and suckled it at her own breasts.'

So readers, too, were nourished by a warm glow of pride at Welsh generosity and humanity. The reporter reflected on emigration and how it is most successful when families and neighbourhoods go together: 'There is no loneliness, no misery save through the unavoidable accidents of life.' Crowds gathered to see the departure of the SS *Polaria* at 9.00 p.m. on Wednesday. Some expressed their wish to join the emigrants. Thirty men went to the captain and offered to work their passage. Fifty 'loafers and would-be stowaways' were discovered and sent back in the steam tug, as the ship sailed away.

The SS *Polaria* was carrying ordinary people, prepared to do something extraordinary in order to build a new life. There are still many across the world who are forced to leap into the unknown for a better life, and today some of them come to Swansea. In 1882, Swansea waved them goodbye.

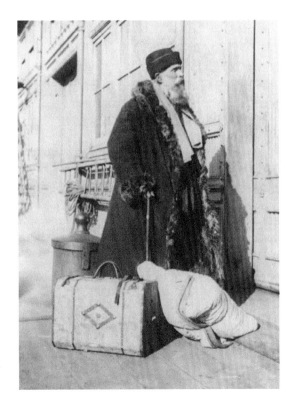

At the door to a New World. (By kind permission of the American Library of Congress)

Quay Parade

These days Quay Parade generally lacks a certain drama, which is just as well, since it is a major route into the city. At the time of writing, there is a fading shopping centre on one side of the road – valued more for its parking than shopping opportunities – and on the other side of a busy dual carriageway is a supermarket. It isn't a place where there is much reason to stand and stare. We just need to endure it.

Our ancestors took much the same view of it. Except they had a problem. The route didn't always flow too well: if the lock gates were opened for shipping then the good people of St Thomas had to wait to cross the dock in order to get home. And they didn't find it a particularly congenial place in which to linger.

Of course, there were shipping and insurance agents, solicitor's offices, and warehouses. There was a tobacconist, a metal merchant, potato merchant, a dry dock – all serving the needs of a busy port. But there were also sailors and other visitors, looking for relaxation and recreation. And it was their urgent personal needs that were the problem.

It was never a good place to be a policeman. 'Drunkenness and incapability' were indissolubly linked to Quay Parade and officers were always being assaulted by men and women who would later have no memory of it. For example, take the case of James Bruter, a member of a group of seamen who were drunk and disorderly on Quay Parade in April 1871. They were swearing and looking for a fight so PC 24 told them to clear off. Bruter took off his coat and his friends shouted, 'Knife him!' It was not a pleasant situation. PC 24 bravely told them that if they did not board their ship they'd be arrested. So Bruter attacked him and thumped him twice in the mouth. PC 16 came to his assistance, and Bruter was arrested. He was fined £3 and had no recollection of the events at all.

In an attempt to change the atmosphere, the Lifeboat Coffee Tavern was opened on Quay Parade in October 1879, 'establishing in this drink-loving country a place where people can get wholesome and harmless victuals and recreation at moderate charges.' It was part of the temperance movement and similar premises opened in other parts of the town. The success of this attempt to 'grapple with the grievous evil of intemperance' might most charitably be described as mixed. Clearly, in public

houses there were 'temptations inseparable from them which had no place in coffee taverns', but for some this was in fact the whole point. A coffee tavern was never going to hit the spot. It certainly didn't make Quay Parade any easier to police.

In 1897, PC O'Neill attempted to move on a drunken tramp who was arguing with sailors. The man turned on him and stabbed him in the side. The wound was slight, since the knife was blunt, but this was a dangerous place where robberies, assaults and rowdiness were commonplace.

In 1919, the council identified the stretch between the Post Office and the North Dock as the most difficult part of town. They had been picking up drunken sailors lying on the pavement for years, and women were regularly assaulted: 'If women stopped for a tram at the bottom of Wind Street they were accosted by foreign sailors and in some cases taken hold of.' They wanted better lighting along Quay Parade. In fact, it had been one of the first places to be lit by electric lights in 1894. It had to be.

Every aspect of urban poverty was displayed there. In December 1888, Cecilia Collins, 'a poorly-clad woman ... with a babe in her arms', was prosecuted for sending her sons out to beg in the street. In defence, she said, 'They can't steal, and so they must beg.' She had neither food nor fire. She was cautioned. In 1882, Thomas Holland stole two beef tongues from a butcher's shop on Quay Parade. Twenty years later, in 1902, William Donnell, a seaman of no fixed address, trumped that by stealing a pig's head. He was fined 20s.

There were other issues too. In July 1883, Henry Taylor, a captain in the Swansea Salvation Army, was summoned by the police for obstructing the public thoroughfare when a large crowd gathered on Quay Parade to listen to members singing hymns. When the police told him to move on, he ignored both a constable and a sergeant, who became seriously irritated. It was a public thoroughfare, people were returning from the market and cabs couldn't get through. When the police started to take their

Fat was in the Fire.

On Thursday afternoon, shortly before five, the fat got in the fire and caused damage in a kitchen at the back of 6, Pier-street, used by Mr. Wm. Woolf, fish dealer, Quay Parade, Swansea; for frying fish.

P.C. Horner was called in, and bravely penetrating the kitchen regardless of the staggering effluvia emitted by the burning fat, put the fire out in a short time, with the aid of sundry buckets of water, but not before a good deal of the woodwork fittings in the kitchen had been destroyed.

PC Horner – the sort of man who can take effluvia in his stride. August 1905. (By kind permission of SWW Media)

names, the trumpeter went on his knees and prayed that the Almighty would have mercy on the policemen's souls. PS Smith was less charitable. He was not impressed by their singing. He said that the Salvationists conducted themselves 'like showmen and madmen and wild beasts'. In return, Taylor accused the police of 'pulling him about most shamefully', and witnesses said that the police were much more like wild beasts than the Salvationists. A woman said that the police had grabbed Taylor by the throat. As far as the magistrates were concerned, the law was perfectly clear: no one was allowed to obstruct the public thoroughfare. The accusations against the police were dismissed, and Captain Taylor was fined 5s and costs.

There was further problem a few weeks later in August when Revd Thomas George, one of the curates of the Swansea Parish Church, was also summoned by the police for causing an obstruction on Quay Parade. With several members of the Church Army, he held a protest service outside Allsops the brewers. The police sergeant accused them of causing an obstruction, and the court decided the defendant should pay 10s plus costs.

In 1907, the varicose veins of Jeremiah Flynn burst when he was opposite the Lifeboat Coffee Tavern. He staggered over the road with blood pouring from him 'as if from a spring'. A crowd gathered, but it was PC Thompson who arrived to save the day. He staunched the flow of blood with a tourniquet until the ambulance collected him and took Jeremiah to the Union Infirmary where 'four stitches were put in by Dr Bury'. Oh yes, times were often exciting on Quay Parade.

R

Richard Rees

There is a remarkable gravestone in the cemetery in the parish church at Llangyfelach, just inside the gate on the right-hand side. It maps out in awful detail the unthinkable tragedy of the family of Richard and Hannah Rees of Graig Trewyddfa. In a period of twenty years between 1865 and 1885, they had ten children, all of whom died in childhood. They are remembered on the ageing gravestone pictured, which has a terrible and chilling litany. It is impossible to imagine how anyone could have found the emotional strength to deal with such loss. I wanted to find out more about Richard and Hannah so that in some way I could try to connect with them as a mark of sympathy, but I have been unable to find anything. They remain as merely names on a gravestone, people who had to deal with something I find unimaginable.

In Wales, of course, the number of surnames used is limited and as I was looking vainly for more information about Richard Rees of Graig Trewyddfa, I came across many others who shared that name. What emerged was a peculiar catalogue of sadness and oddity, with a fair amount of drunkenness thrown in, all linked by the same name – Richard Rees. There must have been other Richard Rees' who were respected citizens, but they remained well below the radar.

We start in 1830, when he was an ironmonger who went bankrupt and his stock had to be sold off. However, two years later, he was two years old and was killed by an empty coal wagon on the railway. By 1843, he was the landlord of a pub in Neath called The House of Lords' which, to be honest, is the nearest any Richard Rees here will ever get to a peerage. This one was charged with permitting drunkenness, which you might have thought was part of the rich tapestry of a publican's life.

Three years later, he seems to have been accused of assaulting a policeman. This must have been extremely confusing since PC William Rees was assaulted, allegedly, by David Rees, Richard Rees and Rees Rees. Perhaps, it was some byzantine family argument relating to rent evasion, because that was the reason he was back in court soon afterwards. He did take some time out from a career of drunkenness and assault to defeat T. Jackson of Swansea (the Flying Tailor) in the Mumbles Road Race in 1850, but he was soon back to his old ways. It would seem that his happiest moments came when he was drunk and disorderly.

In 1854 he was charged with riding his cart without reins and, consequently, they refused him a licence to run The Lamb Inn in Greenhill. Instead he ran a shop, under the name Cheap John. In 1866, he took over as licensee of the Grenfell Inn but was soon in trouble. He was selling beer during illegal hours. His wife said it was all the fault of the barmaid, but he was still fined.

Soon he was the landlord of The Dolphin in Ebenezer Street and, when the police turned up at 2.00 a.m., they found five men and two women in the front room, and eleven men and four prostitutes in a skittle alley round the back. It gets worse. There was one man playing the fiddle, his brother was dancing and Richard Rees did not have a music licence. He was warned and fined. In January 1869, he was declared bankrupt, and a couple of years later he was accused of adulterating beer and then again of stealing sand. After this, he appears to have died on 23 December 1870. He left the Mile End pub, a little over-refreshed, fell drunk into the canal and drowned.

Not surprisingly, when he applied for a licence again, this time for premises in New Oxford Street, he was refused. Mind you, it wasn't all bad news. He did win a prize at the Morriston Eisteddfod in the Zion Chapel, though you might begin to suspect that this was a different Richard Rees altogether. It might even have been the one I was looking for. But I know it was not the same Richard Rees who was detained by PC Powell for 'depositing nuisance on the sands'. He was only ten years old and had been

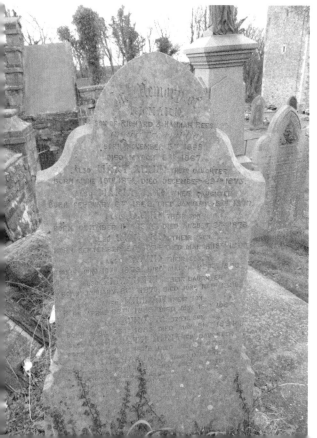

Author's collection.

told to do so by his employer. However, he could have been the one who was detained after deserting the army in 1894.

By 1876, he was an engineer with a wife in delicate health. He sent her to stay with family in Llanelli, where she would be better looked after. Their six children stayed in Swansea and his wife's younger sister Eliza Stevens moved in as housekeeper. I think you can imagine what happened next. After a couple of months, he packed the children off to Llanelli to their mother, and he and Eliza eloped. The police fired off telegrams everywhere and he was arrested in Liverpool while in company with his paramour at a hotel. The police came to collect him and Richard Rees was taken back to Llanelli, where the magistrates sentenced him to three months hard labour. Poor Eliza was left behind in Liverpool.

Poor Richard Rees. Perhaps not his best century.

Ellen Sweeney

Ellen Sweeney was a gift to court reporters. On a slow news day, they could rely on her to give them the material they needed with the story of yet another conviction. Even after her death, she has remained there to help out those who research the second half of the nineteenth century and require a colourful story. By the time she died in the workhouse in August 1896, where she had been ill for two months with 'enlargement of the liver', Ellen Sweeney had appeared in court on 278 occasions, almost always for being drunk.

Ellen was born, probably in 1840, into a dysfunctional family in Greenhill. Her sister Mary had a string of convictions for drunkenness and, on the rare occasions when he hadn't drunk himself unconscious, her brother Michael tried to make others unconscious by hitting them. Neither achieved the same level of notoriety as Ellen. A mere twenty-seven appearances in court show Michael's distinct lack of effort.

Ellen was fourteen when she first appeared in the press in September 1854 and was already working as a prostitute. She was charged with the theft of a purse from John Jones, 'an elderly person, apparently of eccentric habits'. He 'accidentally fell into the company of Ellen Sweeney', who, after 'conducting herself indecently', ran off with his purse. She may have had a child the following year, but we can be sure that she was in trouble for 'disgusting conduct', 'threatening language', fighting with other women and assaulting policemen and drunkenness. Always drunkenness. Sometimes the court observed that she was far too drunk to be disorderly, but on other occasions she could be exceedingly difficult. In March 1859, it took three policemen to subdue her. By the time she was twenty-four, she had been charged at least forty times and the press started to think it might be a good idea to keep a more accurate record.

On her release from custody, her habit was to go into a public house, order a glass of spirits and threaten to smash all the windows unless she received the drink for nothing. Prison was clearly a price worth paying for a free drink. It was not unusual for her to appear in court, promise sincerely to reform her habits and beg forgiveness. If her offence could be overlooked, she would never touch another drop. The magistrate would generously show compassion and by the evening she would be arrested, 'once again helplessly intoxicated'. They had no idea of how to deal with

Ellen Sweeney, drawn during a court appearance.
(By kind permission of SWW Media)

her, for 'neither severity nor leniency seemed to have any effect'. She was regarded as a complete nuisance. In October 1872, after she'd been breaking windows again, she said, 'I am not going to walk an inch for any Government establishment anymore; send for a stretcher' and so she was carried to the police station: 'The High-street was completely blocked up in consequence of prisoner's conduct.' She was sent to prison.

In 1865, Ellen was charged with stealing a silver watch from Henry Davis, a joiner, who, when drunk, foolishly went to a brothel with her, where he was robbed of his watch and beaten up. She was sentenced to eight months' imprisonment. On the day of her release she was found helplessly drunk in High Street. In February 1873, she was sent to Cardiff gaol for twelve months for repeatedly damaging property. When she came out, she lasted a week before being sent back inside for a month. In 1875, she was again sentenced to twelve months. Within a week of her release, in May 1876, she was back in prison.

An editorial in March 1875 expressed some sympathy towards her:

> When out of gaol she is incapable of resisting this craving for strong drink and, once tasted, nothing can prevent her drinking until she becomes helplessly incapable. No one knows this more certainly than poor Ellen herself. When in gaol, and consequently sober, she, freely acknowledges her moral slavery, and feels acutely the iron chains which bind her so securely.

The prison regarded her as the best laundress they ever had.

Deep within the historical record is the July 1867 report of her fifty-first appearance in court. She had been rescued by two policemen who'd fished her out of the river after she tried to drown herself. If that was a cry for help, then it was not recognised,

and very soon she was once more found 'in a helpless state of drunkenness' behind the town hall.

The court cases are relentless. In January 1877, she received six months for throwing a jug of water in the face of a police officer who arrested her. In 1879, exasperation led to an inevitable assumption that she must be mad, but the doctors who examined her could not detect symptoms of insanity. Officials were puzzled by the inability of Victorian society to rehabilitate alcoholics – as if there was an easy answer that they were missing. They were aware that their strategies had no effect: 'A teetotaller while in prison, and exceedingly tractable and orderly; yet no sooner does she taste the cursed drink than she is unfit for liberty.' There was much soul-searching, hand-wringing, even poetry. The poem 'The Ballad of a Gaol Bird' had been printed in 1890 and was written by 'PC'. You may appreciate his need to remain anonymous when you consider that the last verse contains the lines,

> But there, 'tis no use, now, to coax me
> I can't, if I would, mend my way;
> The dog will return to its vomit,
> In spite of what good people say.

By 1892, Ellen Sweeney had spent sixteen consecutive Christmases in Swansea gaol. In December 1893, and in prison again, the news was that she was seriously ill. However, she recovered enough to be released so that she could be arrested once more. Carrying the weight of her convictions on an emaciated and ravaged frame, she was laughed at and abused by young boys on the streets. It seems that prison was the only place her life had comfort and meaning, but, inevitably, as she staggered towards the 300 convictions that the press so fervently hoped for, her body and liver started to give up.

She died in the workhouse. She faded into the darkness listening to prayers whispered to her by two prostitutes kneeling by her bed, as they waited vainly for the priest to turn up. Her death 'deprived Swansea of the distinction of possessing one of the greatest female inebriates in the kingdom ... "Poor Ellen. We will miss her"'.

She left the whole of her effects to the undertaker to provide for her funeral. The sale of her assets realised £1 18s, and she was buried in Danygraig Cemetery on 24 August 1896. She would ultimately share this unmarked grave with her brother Michael, who died in Cardiff Poor House in 1908, and her sister Catherine from Wellington Street.

Tank Bank

As the First World War became embedded in the thick mud of stalemate, by the end of 1917, the British government was desperate to raise money to sustain their forces. Consequently, they developed a scheme to sell war bonds and savings certificates by exploiting the public's fascination with a new super-weapon – the tank.

They were regarded as remarkable things – triumphant British technology that would guarantee humiliation for the Germans. So a battered tank named *Egbert* was displayed in Trafalgar Square, and the public queued up and bought bonds. This was a Tank Bank. Soon it became a national fundraising campaign. Tanks toured the country, inviting the public to see the new machines and invest in War Saving Certificates. They were sold at 15*s* 6*d* and would be returned in five years' time as £1, representing 5.4 per cent, tax-free interest. Investors were described as 'Fifteen and Sixers'.

Naturally, Swansea was eager to play its part. And so after visiting Southampton, *Egbert* turned up in Swansea at the beginning of January in 1918 and was placed in Guildhall Square. Swansea was eager to raise more money through *Egbert* than Llanelli could raise through their tank *Julian* and especially desperate to defeat Cardiff's total.

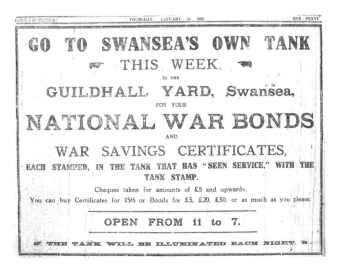

By kind permission of SWW Media.

The Corporation set things off by investing £25,000, and other local companies followed. But it was the ordinary man's money they wanted, especially that of the many in Swansea who did not have bank accounts. They turned up with their savings in small change, some even with their small horde of gold sovereigns, to feed 'the ambling monster's insatiable appetite for money'. It created huge interest and drew enormous crowds in spite of the snow.

To fuel patriotic fervour, Mrs O'Brien, mother of Sergeant Pat O'Brien of the Swansea Battalion, was presented with his posthumous Military Cross from the tank. Sergeant J. Brazell of the Welsh Regiment was presented with his Military Medal and they would have liked to have given the Military Cross to Captain Haydn Rees of Clydach, but he was busy. John Doran, who was appearing at the Grand Theatre – 'a brilliant exponent of all that is best in histrionic art' – gave patriotic readings.

Each tank cost £5,000 and was expected to kill 5,000 soldiers – effectively a pound a head, which was apparently regarded as a bargain. However, parked near the tank on its last night was the motor ambulance presented to the Swansea Battalion by Swansea Master Bakers – a reminder of what lay beneath such military enthusiasm.

The tank crews, which came to South Wales, had been told it was the home of 'pacifism and peace cranks', and obviously not everyone was convinced by the scheme. Some took the view that by investing in bonds, they were helping the government and effectively prolonging the war and the suffering. Whether investors were driven by patriotism or rather by the desire to get some good financial action isn't clear. It may have been a contemporary myth, but it is said that an old lady went to give money but said she couldn't find the slot into which it should be dropped.

On 15 January, the performance at the Grand Theatre was interrupted by sustained cheering after the final total of the money collected was announced: £1.18 million had been subscribed, easily beating Cardiff. This encouraged councillors to demand that Swansea be made the capital city of Wales. Swansea came fourth in the UK league table when calculated per head of the local population, beating Manchester, London and Birmingham – and Cardiff. Edinburgh might have been top, but beating Cardiff was regarded as 'Swansea's finest day'.

Egbert left for Preston. But the tanks had not finished with us. There were exciting scenes in Gorseinon and Pontarddulais when the tanks returned in June. *Egbert* was in Gorseinon for a day and collected an amount equivalent to £32 per head of the population, a record for the country. It proved 'emphatically that Gorseinon should be regarded as one of the most patriotic towns in the kingdom'. Pontarddulais had a visit from two tanks on the same day on 22 June 1918. They didn't raise as much as Gorseinon, but had more individual investors. Both places claimed the contributions of investors from Grovesend as their own.

There was a similar scheme for ships. Money was getting tight but, having done so well with the tank, they thought it was a good idea for Swansea to aim for something

T

By kind permission of SWW Media.

bigger – a cruiser. Led by local business men – who made significant investments – Cruiser Week too was a success in March 1918.

Then, in July 1918, there was War Weapons Week. Everyone was urged to do their best: 'a long pull, a strong pull and all pull together'. If they raised enough money, they could have a tank named after the town: 'Just imagine the enthusiasm of our Swansea Boys when they see the tank "Swansea" going into action before them.' Indeed.

In the end, Swansea raised over £12 million pounds from these appeals. As a result of their success, they were told in March 1919 that they had been allocated their very own tank as a permanent memorial of the war. Tank 150 was sent from the Tank Corps Depot and eventually 'installed after a lengthy and adventurous trek through miles of streets' on its concrete base at the Mumbles end of the Recreation Ground on Tuesday, 3 June 1919. A crew that brought the tank then removed its machinery and it was left to rust in peace.

The tank did not receive universal acclaim. One councillor said it would only become an eyesore. Another thought it best to sell the tank as scrap iron. Nevertheless, it paraded through Swansea accompanied by telegraph messengers, discharged soldiers, a captured German gun and the police band, but it didn't go well. It had arrived in Hafod by train, where it had demolished a fence while being unloaded 'with a playful swish of its tail'. Since it hadn't been driven for a while, its emissions were toxic and progress was slow. It took more than one-and-a-half hours to reach the Palace Theatre – it was over-heating due to a dodgy fan belt.

It had seemed like such a good idea. But once it turned up, no one was quite sure what to do with it. It was an emasculated relic of the past, rusting forlornly. It did indeed become an eyesore and was melted down for scrap in the Salvage Drive of 1942. In a new incarnation, it fought a world war for a second time.

SWANSEA'S TANK

PLAYFUL SWISH OF ITS TAIL KNOCKS DOWN FENCE

(BY A TANK SERGEANT).

Swansea's war savings tank on Tuesday afternoon proceeded one little stage further in its journey from Tank Corps Depot to its final resting place (yet to be prepared) at the Mumbles end of the Recreation Ground.

It arrived at the G.W.R. goods station on Monday, and on its truck—not of the modern, large, very finely constructed type, built to carry 40 tons, that we saw on the other side, and of which complete trains were taken across on the famous ferry, but a smaller, home service one—was shunted to a convenient point for unloading.

Both images by kind permission of SWW Media.

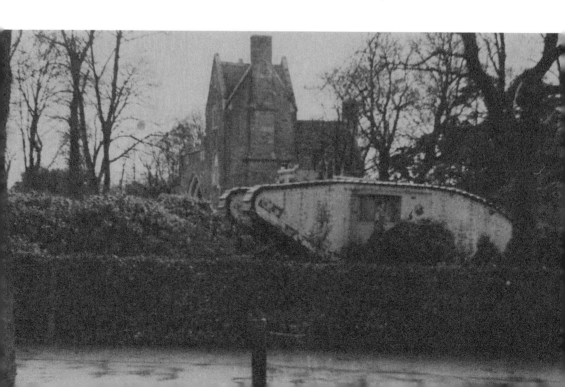

U

The Uplands Cinema

The Uplands Cinema features in this book as a representative of those suburban cinemas that sprang up all over Swansea and then disappeared just as quickly. At one time, almost every community had one, such as the Manor Cinema that was in Manselton or the Maxine in Sketty. Morriston had the Gem and the Regal, in St Thomas you could visit the Scala, and in Mumbles the Tivoli. They were palaces of entertainment, with deep carpets and luxurious fittings that turned an evening at the cinema into a special occasion. It wasn't just the screen that offered a glimpse of another world. It was the building too, so different from the audience's modest homes.

Sadly, of course, such a diverse provision could not survive, and the arrival of television in 1952 effectively brought an end to the local picture house. The very best that the cinema could offer was now brought directly into your home, saving you the bother of going out into the dark and the rain.

The Uplands Cinema opened at Easter 1914, in what the press described as 'one of the best-class districts in Swansea ... The evening performance will commence at 6.30 p.m., and at the matinees afternoon tea will be provided free of charge'. It beats popcorn in my view.

The cinema was built on the corner of The Grove and was designed by Ben Jones of Wind Street to provide an estimated audience of five hundred with a constant supply of pure air:

> while numerous windows and skylights admit the cleansing sunlight which is so essential to a fresh and thoroughly sanitary interior ... an orchestral instrument, comprising both piano and organ, has been installed, and is manipulated by a talented young lady ... The films shown will always be of the highest standard of respectability, as well as the last word in bioscopic art.

All the seats in the circle 'are excellently upholstered tip-up chairs' and 'the lighting system is also of the most modern class'. This is clearly an important issue:

> In a large percentage of picture halls the sudden illumination after the showing of a picture has an injurious effect on the eyesight. The management of the Uplands Hall, however, have taken great interest in the matter of the lighting, with the result that the illuminants rise gradually, and with a pleasing effect.

Interest in the films themselves, as opposed to the lighting, was promoted in a weekly column 'Stage and Stalls' in the *Cambrian Daily Leader*, which was intended to whet the audience's appetite about the thrills available to them across the whole of Swansea.

The programme would usually contain a number of short films, both comedies and documentaries, supporting a main feature. At the Uplands' premiere that was *The War Makers* featuring Mr Maurice Costello and Miss Julia Swayne in 'a thrilling story of high diplomatic circles'.

In November, the people of Uplands had the chance to watch the doings of *The Mysterious Leopard Lady*. This thrilling drama was notable because it was directed by a woman, Grace Cunard. It was one of a small, but important, number of early films that featured female action heroes. The programme also featured *The Warwick Bioscope Chronicle*, which 'portrays the events of the day in moving pictures'.

I am quite sure that, in December 1914, they were queuing down on to Walter Road to see *The Misappropriated Turkey*, in which a striker puts a bomb inside a turkey that, unfortunately, falls into the hands of some poor children who take it home. As bizarre as it sounds, this unpromising seventeen-minute drama was directed

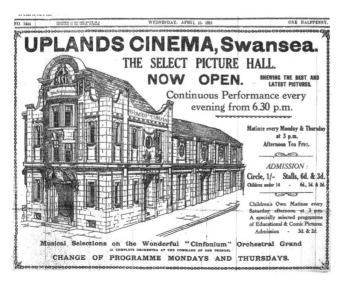

April 1914. (By kind permission of SWW Media)

by the legendary D. W. Griffith. The intervening years seemed to have ignored it, notwithstanding the very exciting climax when the bomb is removed from the house at the last moment. I still worry about the turkey to be honest and must assume that it was already oven-ready when the striker inserted the bomb. Any alternative is just too painful to consider.

On this occasion, 'a liberal number of comical films are included in the programme, of which "Billy's Love-making" is one of the most laughable'. You will not be surprised to learn that this title troubled the Pennsylvania State Board of Censors, but, naturally, did not exercise a sophisticated audience in the Uplands. Other short films included fascinating titles such as *Was Pimple Right?*, *Avenged by a Fish* and *Bertie Buys a Bulldog*. I think I would like to see the one about the fish.

The Uplands wasn't just used for films. In November 1914, an evening concert was held to raise money for the Swansea Belgian Relief Fund:

> Not a vacant seat was to be seen in the hall, which had been tastefully decorated with palms and British, French, and Belgian flags. There were a number of musical items including Rachmaninoff's Prelude in C Minor ... Undoubtedly the chief artiste of the evening was Miss Gertrude Reynolds, who both as vocalist and elocutionist scored triumphs. Her recital of The Bandit's Death (Tennyson) was wonderful.

There were several films, among them was *Stricken Belgium*, which gave the audience an idea of the plight of the refugees.

The cinema is remembered too because it was close to No. 5 Cwmdonkin Drive, the childhood home of Dylan Thomas. In his writings, he makes several references to 'Hissing and Booing away his pocket money' at Saturday matinees in one of his favourite places. One of his first published works was a piece for his school magazine about the cinema, which he loved.

At the start of the Second World War, the cinema was closed down and converted into a branch of Lloyd's Bank before it was demolished and then rebuilt in its current squat, unattractive form, a rejection perhaps of the excitement that the building once offered to an audience from 'one of the best-class districts in Swansea'.

John Henry Vivian

Theirs was the most important name of nineteenth-century Swansea. The Vivians – wealthy, privileged, influential. Their copper-smelting company and chemicals business in Hafod dominated the east side of Swansea for over a hundred years and brought enormous wealth to the family and regular misery to those who created it for them. At their peak, these were the largest copper works in the world and produced one-quarter of all the copper made in the United Kingdom.

It all started at the beginning of the nineteenth century, when John Vivian came to Swansea from Cornwall and became a partner in copper works at Penclawdd. By 1806, his second son, John Henry Vivian, replaced him as manager, and the new company of Vivian & Sons leased the land where the Hafod Smelting Works and Mills were established. The partners were John Vivian and his two sons, John Henry and Richard. Richard followed a military career, while John Henry became managing partner.

Ferrara Quay, Swansea (Author's collection)

Richard was a cavalry officer and fought in Spain under Wellington where his bravery was frequently commended. In April 1814, leading a detachment of the 18th Hussars, he was severely wounded near Toulouse while securing an important bridge near the village of Croix d'Ovade. The 18th Hussars presented him with an inscribed sword in recognition of his bravery, while Wellington, more practically, regretted losing 'the benefit of his assistance for some time'.

When John Henry, who was twenty-nine, heard of these injuries, he decided to visit Richard in France and took the opportunity to turn it into a bit of a holiday. He saw his brother in Toulouse and then, with his travelling companion James Wildman, journeyed for the rest of the year, deciding that they must include in their itinerary a visit to see Napoleon, 'the most extraordinary man that ever ruled an empire', who had abdicated and been exiled to the island of Elba in April 1814.

The two men arrived in Elba on 22 January 1815. They had to hang around for a while, until the deposed emperor was ready to see them. They spent their time happily enough, lounging about the town and viewing the imperial stables and stud. They also visited the celebrated iron mines at Rio, on the eastern side of the island. Eventually, they were granted an interview on 26 January 1815. They went to the imperial residence in heavy rain and soon they were ushered into a room, where they saw

> a short man standing by the fire-place. He was inclined to corpulency – he had on a green coat, cut off in front, faced with the same colour, and trimmed with red at the skirts, and wore the stars of two orders. Under his left arm he held his hat, in his hand a plain snuff-box – his hair was without powder and quite straight. He was Napoleon – the Exiled Emperor.

Quite what Napoleon made of this meeting isn't clear. In reports of the encounter you can sense of his amusement that these young men, puffed up with their own importance, believed he might want to meet them. How could he take them seriously? Vivian was dressed in the uniform of the Cornish militia and his friend in that of Kent, and they had turned up in his house to ask for his opinions. So he obliged.

They were with him for just over an hour and their conversation was wide-ranging. There was some general talk about wine and Cornwall and, like travellers everywhere, they talked about the state of the roads. Once he was suitably warmed up, Napoleon went on to talk about international politics, which was far more interesting. Napoleon said that Russia's power would keep on increasing and that England's power and influence would decline. As far as Italians were concerned, they had a fine country, but he found them effeminate and more interested in spending their time with women. He said that the existence of a Pope was a great misfortune for Europe. He regarded the government of priests as detestable and said that England should be grateful to Henry VIII for getting rid of the Pope. England and France should be allies,

By kind permission of
Dennis Jarvis.

he said. After all, the world was large enough, and France had never wanted to meddle too much with commerce. Napoleon was not afraid to express strong opinions and talked about the capabilities of different armies: the Spanish Army was obstinate and English soldiers, when drunk, were ungovernable. You have to think that Napoleon was enjoying himself. Vivian was, of course, awestruck. He wrote later,

> I never passed an hour or indeed an hour and a quarter more agreeably. We stood during the whole time, I may say almost nez a nez, for I had my back against the table and he had advanced close to me, looking full in my face. After the first few minutes I felt most perfectly at my ease.

As a good citizen, Vivian sent details of the conversation to his brother, who in turn passed it on to the Prime Minister, Lord Liverpool, as an insight into what the deposed emperor was thinking. Perhaps he should have kept him talking a bit longer. A month later Napoleon fled from Elba, reached Paris, expelled Louis XVIII and for his pains

'*Mes braves!* I bring news of my meeting with John Henry Vivian.' (Author's collection)

was declared an outlaw. The inevitable consequence was his defeat at the Battle of Waterloo in June 1815.

However, Napoleon hadn't seen the last of the Vivians. Because while one talked to him, the other fought against him. Richard led one of the cavalry divisions at Waterloo. It is felt by some analysts that his contribution at Quatre Bras was a decisive moment in the battle, ensuring Napoleon's final defeat.

After unwittingly encroaching upon a significant moment in European history, John Henry Vivian returned to Swansea with his memories. He wrote a book about his meeting with Napoleon and used the name of the island of Elba as the name for the colliery that provided the coal for the Elba steelworks in Gowerton. He was actively involved in the development of Swansea and his family left an indelible mark, for better and for worse, across so many aspects of life in the town. He represented Swansea as Member of Parliament from 1832 until his death in 1855. He was a Fellow of the Royal Society, a Justice of the Peace and a Deputy Lieutenant. He also had the honour of having a phosphate mineral, Vivianite, named after him. To some, that might be even more impressive than a bronze statue, which is now in Ferrara Square looking towards the National Waterfront Museum.

Wind Street

In the nineteenth century, it was the curved glass windows of *The Cambrian* newspaper offices that attracted visitors to Wind Street. They were a first for Swansea and quite a talking point – a symbol of sophistication and prosperity. Of course, Wind Street still attracts visitors, but, in the twenty-first century, they have a very different agenda.

It has been described as 'an area of drunkenness and debauchery', a 'magnetic attraction' for drinkers eager to spend as much money as is necessary for them to collapse in a disjointed heap in front of a drug dealer. You can apparently buy guides to drinking on Wind Street, should you need one.

Of course, most of us don't go there, especially after dark. There comes a time in everyone's life when you realise that you don't have to any more. Getting old isn't so bad after all. Traders claim it has a 'broad demographic', which means that you wouldn't take your children there after tea time, unless you want them to see strangers urinate against restaurant windows in Swansea's 'café quarter'. Perhaps the planners who tried to regenerate Wind Street hoped for something a touch more sophisticated, but what they managed to create was a record-breaking location. The second highest number of incidents reported to the police from any street in the UK, and the third worst street for violence in December 2010. In 2012–13, there were 963 alcohol-related crimes in Wind Street. Not everyone complains. The BBC website, in 2013, published an article under the headline 'Swansea's debauched Wind Street defended by businesses'. No surprises there I think.

To be fair, its past has not always been a distinguished one. In 1842, John Evans, alias 'Fat Jack' a ship-carpenter, was charged with having been found drunk and disorderly in Wind Street one Sunday morning. The prisoner in his defence said that he was very sorry he had conducted himself improperly, especially towards one of the policemen, but he couldn't remember what happened. He was fined 5s for setting a trend that his descendants have been eager to follow.

In June 1844, an unruly mob watched a family dispute the ownership of the Plume of Feathers public house. One half of the family barricaded themselves inside, while the other half recruited some ship's carpenters to break in through the upstairs

windows using ladders: 'Never was there so much excitement in a Swansea street and all through the day pugilistic battles were fought.'

Then, of course, there was a murder in 1914. Sergeant William Hopper, a Boer War veteran, was in charge of an armed unit on Christmas Day, guarding the South Dock against possible enemy saboteurs. They spent some time checking ships for stowaways and, in the morning, the unit were offered plenty of Christmas drinks. Hopper was given a bottle of whisky that went missing and he accused Private Enoch Dudley of taking it. They argued and fought, so an officer sent them back to the Drill Hall. On their way, they argued again in Wind Street and Hopper shot Dudley from close range, with the bullet passing through him and slightly wounding another soldier. Dudley died almost immediately. Hopper said he acted to prevent a mutiny, but was tried, convicted of murder and sentenced to death. The appeal court reduced the sentence to four years' imprisonment for manslaughter. You may not be surprised to learn that the whisky was found in Dudley's pocket.

The street has a long history of mayhem and amnesia; the name itself merely causes confusion. You can identify a visitor because they have usually gone with the 'wind', but local people know differently. The name could indicate that it was the street of wine importers or it might derive from *waun*, the Welsh for meadow. But whatever the origin, this is how we pronounce it.

The shape of the street has not changed since medieval times, and it still curves to match the shape of the original riverbank. It led from the castle towards the south

Author's collection.

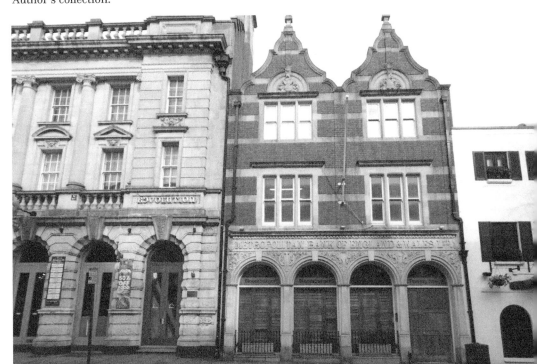

gate of the town and the shore beyond. It survived the significant damage during the bombing in 1941, so it is one of the few streets in Swansea that is much the same as it was at the end of the nineteenth century. If you raise your sights and look at the upper storeys, you can still see a memory of that almost forgotten past when this was Swansea's commercial quarter

Many of the impressive financial buildings are now public houses. The old Midland Bank is called Varsity, reflecting its new commitment to recycle student loans into profits for multinational companies. Barclays Bank acquired the building from which *The Cambrian* newspaper was published, and it has now become the Bank Statement. Lloyds Bank has become Revolution. In the true spirit of our times, the letter 'e' is reversed. Next door you can still see the facia dating from 1893 over the door of a bar that was once the Metropolitan Bank of England and Wales. In 1905, the business had 'assumed such large proportions locally that more commodious premises are necessary', so they moved to Castle Square. The Wind Street branch was still retained 'for the convenience of the commercial men at the docks'.

The finest architectural feature of Wind Street is the Post Office, completed in 1901, at the corner of Green Dragon Lane. It was previously the site of the Mackworth Hotel, which relocated to the High Street. The design of the new building was not

The Wind Street Elevation – architect's drawing from 1897. (By kind permission of SWW Media)

universally welcomed. There were indeed questions in Parliament about the 'great dissatisfaction which existed in Swansea' when the designs were published. The site and the building were expected to cost £47,000, but people wanted something a bit more imposing. Since the government wouldn't offer additional money, the plans were revised to deliver a higher elevation with a tower: 'The offices will be worthy of Wind Street and of the surrounding buildings ... the tower will add very much to the general appearance.' They really wanted a clock, but were happy with four statues on the parapet representing the Home Countries, and the staff gym and practise room for the brass band were on the top floor. The Post Office is also now a bar.

The street is now part of a conservation area. Perhaps the buildings' new use will preserve them, even though it confirms that we no longer need a commercial centre. A more sustainable model for economic survival must today, apparently, be based upon vomit.

Madame X

I cannot offer a complete examination of the complicated story of Kate Jackson, who for a while achieved notoriety as Swansea's Madame X. But the end of her story is very straightforward: she was murdered in Limeslade by her husband Thomas Jackson, who beat her to death with a tyre lever in February 1929.

Kate Atkinson was born in Lancashire in 1887 and ran away from home in search of a career on the stage, probably in 1903. She was soon working as a prostitute in London and weaving a web of deceit for herself.

Thomas Jackson was born in 1890 in Foxhole, where his father ran The Ship Inn. He had worked in Swansea Docks before enlisting in the army on 9 August 1912, where he began an undistinguished career which included ten months in India. He was allegedly planning to emigrate to Rhodesia when he met Kate Atkinson in London, in 1919.

She claimed to be the common-law wife of a French artist Leopold le Grys. She also claimed to be a daughter of Lord Abercorn and a novelist too, writing under the name of Ethel M. Dell, a reclusive writer of popular romantic fiction. It was all lies of course.

They married in Camberwell in 1920 when he used the title Captain Gordon Ingram, allegedly because Kate said that it sounded sophisticated. Of course, once she was dead,

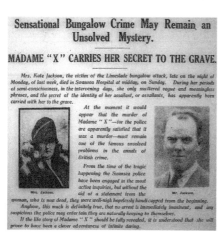

By kind permission of SWW Media.

Kate was unable to speak for herself, and her story was told by Thomas Jackson. He wasn't to be trusted either. He said her lifestyle was recklessly extravagant. She dressed only in silk and had no sense of value. She would make unexplained visits to London and, he said, kept a revolver and ammunition in order to shoot anyone who tried to kidnap her. The reason for this became clear in 1927 when she was called to give evidence in the case of George Harrison, who was accused of embezzling money from union funds under his control.

Harrison had been the Secretary of the National Association of Coopers and, in 1927, he was sentenced to five years' penal servitude in Maidstone prison for embezzling £19,000 from the Association, leaving them with only £3 1s 10d. He had given at least £8,000 to a woman he believed was Mollie Le Grys who, of course, was Kate Jackson. Harrison never profited from the money he stole. He gave her money because she claimed she needed it for 'medical attention'. He had forged receipts for the money, some of which had been raised by a levy of 1s a week in aid of the Miner's Relief Fund during the General Strike.

At his trial at the Old Bailey, Kate was referred to as Madame X, her name withheld in the hope that anonymity would encourage her to return some of the money. It certainly fuelled sensational headlines in the press, as well as her ego, and added to the aura that surrounded her. But when sub-editors described the missing money as 'Money for Miners', these words effectively killed her. Once she gave evidence in her own name and was identified, Thomas Jackson could say people were out to get her. She confirmed she'd received money that she had used to buy a house in Limeslade. She agreed that Harrison had regularly sent her £15 or £20, money some people felt was rightfully theirs. Why was he sending her money? I think you can guess.

Harrison told the police that he had first met Kate on Charing Cross Road in September 1914. There had been a slight motor accident and Kate appeared to faint when she saw it. Harrison assisted her, and she said that she had not eaten for three days. At her suggestion, he took her to a restaurant in Wardour Street. Within hours, he was her client.

She told him that her name was Madame le Grys, daughter of nobility, widow and mother of a son called Leslie. Soon they were meeting weekly. In March 1915, she announced that she was pregnant and needed money for a termination. He paid her £40. Soon, he had a letter from Bournemouth from Mrs Humber (naturally this was Kate herself), saying that urgent life-saving medical attention was required. Consequently, he sent her up to £30 each week, until he was arrested in 1927. And so miners' money had effectively bought the house in Limeslade.

Her relationship with Jackson was a stormy one, with an undercurrent of violence. The adoption of a young girl, who they called Betty, did little to encourage domestic harmony. Kate told neighbours that he had once tried to strangle her. For his part, Thomas told them that he couldn't wait to be rid of Kate. Thomas started a relationship with his next-door neighbour, Olive Dimmock. Indeed, the police believed that Kate was in a relationship with her too.

On 10 February 1929, Olive and Kate went to the cinema and on her return Kate was fatally wounded, apparently beaten over the head with a beer flagon outside her

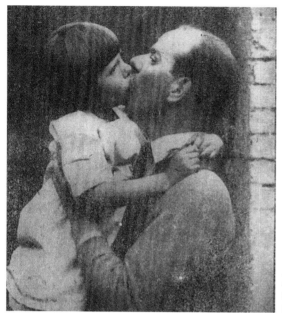

Jackson is reunited with his adopted daughter Betty. (By kind permission of SWW Media)

home. In court, the defence said she had been killed by a disgruntled miner who lay in wait for her. Thomas produced anonymous threatening letters they had received. The police, however, wouldn't buy it. For a start, her blood was not on the outside of the flagon. It was lying broken on the ground, but blood was on the inside of the glass. They believed she'd been murdered inside the house by Thomas and then dragged back outside and left on broken glass. It is interesting to note that, two months earlier, on 10 December 1928, Trevor Edwards had been executed in Swansea gaol for murdering his lover, Elsie Cook, near Bridgend. He cut her throat after hitting her with a beer flagon. Perhaps Thomas thought he could do it better.

The judge was unconvinced by Thomas's defence, and the police knew that he'd done it, but the jury found him not guilty. Perhaps they were entranced by the web of deceit and the ridiculous fantasies that surrounded her and within half an hour returned a not guilty verdict. But the police never looked for anyone else. They knew they had got their man. They knew they had been cheated. They knew that Thomas had done it. He beat his wife to death with a tyre lever. And he got away with it.

Y

'Swansea Youths Die in Sand Bin'

This story has been included as an act of respect to all those who we would regard as children, but who faced the terrible dangers that were routinely inflicted upon them in the world of work, dangers that were accepted as part of the price to be paid for the prosperity that nurtured the town. However nostalgic you can become, never believe that everything was better in the past. It wasn't. Oh yes, apprentices learned their trade on the job, but sometimes the job killed them.

This awful story happened at the Beaufort Wharf on the North Dock, in March 1953. A lorry arrived to collect a consignment of gravel and parked beneath a large metal hopper. It was 26 feet in diameter at the top and held about 100 tons of gravel with a cone at the bottom through which supplies were discharged into lorries.

The gravel started to flow, but unusually slowly. Then a human leg and part of a ladder appeared. Emergency services were called, but they knew exactly what they would find. Oxyacetylene apparatus cut through the bottom of the bin, and in the flow of gravel that followed were the bodies of two apprentices: eighteen-year-old George Thomas from Sketty and John Radmore from the Uplands. Artificial respiration was tried and the boys were rushed away to hospital, but it was too late. They were dead on arrival. Their deaths didn't even make the front page of the local newspaper.

John's father was working as a constructional engineer in Scotland and immediately flew home. George's mother had been widowed during the war when her husband had been lost at sea. Now she had lost her only son.

The two boys were apprentice engineers with the company South Wales Sand & Gravel, and they had been sent into the hopper to recover a ladder that had been left there. They were told to dig down into the gravel to recover the ladder, which was stopping the cone doors from opening properly. It was an unpleasant job, one that was routinely delegated to apprentices. They had to tie a rope to the top of it, then they'd get a crane to lift it out. So in they went.

They were not seen again, and after an hour or so, their older colleagues assumed they had gone off to another job somewhere on the dock. But they hadn't. They were struggling and drowning in the fine gravel, having probably fallen into a void caused by the ladder that had broken into a number of pieces.

SWANSEA YOUTHS DIE

Only a trickle, then a leg appeared

Friends thought them elsewhere

THE SAND BIN AT THE NORTH DOCK BASIN WHARF
" It was a horrifying sight to see these boys coming out."

A N hour and 20 minutes after two apprentice fitters were seen in the vicinity of a loading bin capable of holding about 100 tons of sand, a lorry was driven under it for loading at Swansea North Dock basin yesterday. A lever was adjusted and the mouth of the bin opened. The sand only trickled out. Then a human leg and part of a ladder came into sight.

Oxy-acetylene apparatus was used to cut away the bottom of the bin, which is situated at the Liverpool wharf and in the flow of sand that followed there emerged the bodies of George Thomas, aged 18, who lived with his widowed mother at Cory-street, Sketty, and John Atherton Radmore, aged 16, of Windsor-street, Uplands.

It is understood that the youths, who were employed by the South Wales Sand and Gravel Company, went into the sand-bin to retrieve a ladder. There were between 60 and 70 tons of sand in the bin at the time and the ladder had been placed inside to enable some work to be done.

Thomas and Radmore were not seen again and neighbouring workmen believed they had left to attend to another job. ...applied artificial respiration.

CORONATION DINNER was held 1 opening of their cricket club's new Arlott, B.B.C. commentator; W. T. Wales and Leicester. Included in t L. Blewett, W. M. Leleu, Len Matthe

New president of Grocers' Association

By kind permission of SWW Media.

The chilling reality is that work continued normally on the dock while the two boys were losing their fight for life in the gravel hopper. Once they were stuck inside, there was no way out, and you can imagine them struggling desperately and sinking lower and lower, perhaps hanging on to useless fragments of the ladder.

When the lorry arrived to be loaded, colleagues looked casually down into the hopper, but they couldn't see the apprentices and, therefore, assumed they'd gone somewhere else. So they opened the cone and a couple of tons of gravel came out – then a human foot: 'It was a horrific sight to see these two boys coming out of the bin. They were two very likeable fellows and it was astonishing to realise they had been in the bin so long without anyone knowing their plight.'

The only verdict that could be considered was that they had asphyxiated after being buried in the gravel. The coroner was quite clear. It was an accident. How could anyone possibly be blamed? It was the sort of thing that happened at work. There were apparently no lessons to be learned.

Swansea's past is full of industrial accidents, and they often involved apprentices. There were so many different ways to die: falling from the rigging, falling from scaffolding, or falling down a mine shaft. You could be crushed by rocks or squashed by machines or electrocuted. You might even find an opportunity to be lost at sea. In November 1809, James Drew, an apprentice, 'whilst employed aloft' on the brig *Times* in Swansea's river 'fell from to the deck and died'. A hundred years later and this sort of thing was still happening. In January 1909, George Beynon, aged eighteen, was struck in

the abdomen by a piece of flying metal and died. In December of that year, Mandesley Adams, an apprentice on the railway, had a leg amputated after a train ran over it.

Also in 1909, there was the story of young George Lang from Foxhole, who was employed in a workshop on Bath Lane. He was asked to repair a leak in a petrol tank – with a blow torch. It was perhaps the sort of job that you ask an apprentice to do, particularly if you didn't fancy it yourself. What else are apprentices for? Inevitably, of course, there was an explosion. It blew out all twenty-two windows in the workshop, but surprisingly George was only slightly burned in the face. Thankfully, he was able to carry on with his work.

George Lang was very lucky. He survived. But hundreds more boys like Beynon, Adams, Drew, John Radmore and George Thomas didn't.

Back in March 1843, the apprentice of Mr Reece of Wind Street was 'engaged in preparing some composition on the fire, composed of combustible drugs, which accidentally caught fire'. When he tried to throw the container into the street, his apron burst into flames: 'In consequence of the prompt exertion of Mr. Cock, grocer, no serious damage took place, beyond the boy's hands being severely burned.' Well that's all right then.

Zeno

Our parade through the Swansea alphabet reaches its conclusion with the unique and largely neglected story of Zeno – war hero, meat buyer, spy, author. He was an intense and troubled man who followed his estranged partner to Swansea in March 1958 and then murdered her new lover. But this tragedy was merely the most straightforward part of a complex and fascinating story.

Let us start with the obvious Swansea connection and the *Evening Post* headline from 24 March 1958, 'Murder of Hotel Manager Charge'. Gerald Theodore Lamarque, a 'well-spoken meat buyer', had stabbed Eric Batty, the manager of the Mackworth Hotel, at 10.00 p.m. on Saturday. Batty died in hospital a few hours later. Lamarque had been detained by guests, though he made no attempt to escape. Following his arrest and in all of his subsequent court appearances, he said as little as possible. On his first appearance in court, all he would say, apart from requesting legal aid, was 'I wish to ask no questions your honour.'

Eric Batty came from Merthyr and had been married twice. He had served in the war as an army major and was, by 1958, middle-aged, fat and bald and with, strangely, a reputation as a ladies' man, which led one colleague to warn him that he was digging

HOTEL CHIEF STABBED
Stranger is charged with his murder

Western Mail Reporter

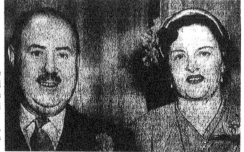

SWANSEA police said last night that Gerald Theodore Lamarque, aged 46, of no fixed address, had been charged with the murder of hotel manager Mr. Eric Batty, who was found stabbed in a corridor near the bar after he called "time" on Saturday night.

Lamarque will appear before Swansea magistrates this morning. Chief Inspector Thomas Dunford said police believe Lamarque, a stranger to Swansea, is British. He has no known occupation.

Eric Batty on his wedding day. (By kind permission of SWW Media)

his own grave. Lamarque killed him because his ex-lover, Mrs Molly Payne, had refused to return to him and instead had 'associated' with Eric Batty. She had once, in 1953, left her husband to live with Lamarque in London but then left him in 1956 and returned to her parent's home in Corrymore Mansions, a block of flats on Sketty Road.

The three of them had met for drinks in the hotel bar, but, as Lamarque calmly told the police, he had with him a knife he had bought in Swansea 'in the event I should have cause to use it'.

When the case came to the assizes in July 1958, proceedings lasted only two minutes. He pleaded guilty and was sentenced to life imprisonment. His only other comment was 'I have nothing to say.'

However, the story doesn't end there. An account of the Battle of Arnhem, in 1944, called *The Cauldron* was published in 1966 and was extremely well received. It focused on a unit of paratroopers confronting a vastly superior German army. The *News of the World* said it was 'a book by a hero, about heroes', and it is still a much sought-after volume. The author, who was serving a life sentence in Wormwood Scrubs for murder, used the pseudonym 'Zeno'. He wrote three other military novels, one of which, *Play Dirty*, became a film starring Michael Caine. Zeno was later identified as Kenneth Allerton, who died in 1978, according to an army obituary – except no death in that name had been registered. Allerton was another alias for our man, Gerald Lamarque.

Lamarque was born in June 1920 and died on 28 October 1978 – the same date as that given to Allerton. He had experienced a difficult childhood in the east end of London. Most of the time he played in the streets with his friend, Kenneth Allerton, until he was caught stealing money and was sent away to a reform school near Southampton. He ran away from the school and is next heard of in 1939, when he appeared in court for stealing two cars and being AWOL from the Royal Dragoons. He was sent to military prison. After his release, he was in trouble again in 1941 – this time for stealing both the mess funds and the regimental silver while stationed in Northern Ireland. He was sentenced to eighteen months with hard labour, but escaped from military prison in Carrickfergus

LIFE SENTENCE FOR KILLER OF MANAGER

Guilty plea to hotel stabbing

GERALD THEODORE LAMARQUE, aged 38, an unemployed meat buyer, of no fixed address, was at Glamorgan Assizes at Swansea to-day sentenced to life imprisonment when he pleaded guilty to the murder of 46-year-old Mr. Eric Batty, manager of the Mackworth Hotel, Swansea.

By kind permission of SWW Media.

and went on the run once again. In order to evade his pursuers, he assumed the name of Kenneth Allerton and cleverly re-enlisted, this time in the Royal East Kent Regiment. In this identity, he became a hero. He served in North Africa and at Arnhem with the First Airborne Division and was promoted to the rank of Second Lieutenant. The army said of him that 'he will always be remembered with pride for the standard of his leadership in battle, his fearlessness and his cool assessments of situations under extremes of pressure'.

He married Dorothy Downs in 1941 and together they had three children, naturally called Allerton, which was probably a considerable shock to the real Kenneth Allerton who lived in Clacton.

After his discharge from the army he became involved in the black market, supplying meat to restaurants in London – a dangerous occupation. He seems to have carried a gun at all times and may have been working for British Intelligence, perhaps attempting to infiltrate the Irish Republican movement. This may explain why the family home in Kent was burnt down in 1952 in mysterious circumstances. In 1953 he left his wife for Molly Payne and, when she left him in 1956, Làmarque threw himself off Blackfriars Bridge in London, but was rescued by a boat. Consequently, when he pursued Molly to Swansea, he was already on probation after pleading guilty in court for attempting suicide.

By remaining silent in the Swansea court, Lamarque's peculiar past was never revealed in court. In Wormwood Scrubs, he formed a close relationship with the spy and double agent George Blake. When he fled to Russia in 1966, Lamarque was initially suspected of complicity in Blake's prison escape.

His imprisonment seems to have brought him some peace and opened up a literary career. He was given the Arthur Koestler Award, which promotes artistic achievement among offenders, for *The Cauldron*. Zeno's book *Life* is a moving and revealing account of his imprisonment. It is absolutely clear that he expected – indeed wished – to be hanged following the murder of Batty. He says, 'I had little interest in life ... what I had supported all my life (ie the death penalty) had been denied me.' After his release he wanted to return to the simplicity of life back in Wormwood Scrubs, where he had lived 'a life of reasonable tranquillity' and yearned to live somewhere remote.

He served nine years in prison and following his release under licence in 1967, Lamarque married one of his prison visitors who became the mother of three more of his children, this time under his original name. The Allerton family remained a secret. Initially, the Lamarques moved to Malta, but were expelled when the Maltese government learnt of his past as a murderer.

Those who knew him after his release speak of an evasive and sometimes contradictory man. He told some that at the age of sixteen he had fought in the Spanish Civil War and that he had been an army major in India. He talked about using the alias 'Valentine Dillon', that he had strangled Batty using his commando training and had called the police himself. He said that they had congratulated him on killing a man noted for his cruelty. He seems to have told so many stories that the truth was hard to distinguish. One fact, however, is inescapable: Lamarque died of pneumonia, in 1978.